KU-538-903

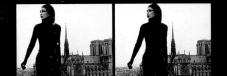

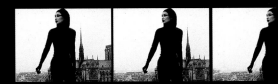

LEE SERVER

ASIAN POP CINEMA

BOMBAY TO TOKYO

CHRONICLE BOOKS
SAN FRANCISCO

This book is for Elizabeth and Terri, two great ladies.

Copyright © 1999 by Lee Server.

All rights reserved. No part of this book may be reproduced without written permission from the Publisher.

Library of Congress Cataloging-in-Publication Data:

Server, Lee.
 Asian pop cinema : Bombay to Tokyo / by Lee Server.
 p. cm.
 Includes bibliographical references and index.
 ISBN 0-8118-2119-6
 1. Motion pictures—Asian History. 2. Motion picture
industry—Asia—History. I. Title.
PN1993.5.A75S37 1999
791.43'095—dc21
 98-5843
 CIP

Printed in Hong Kong.

BOOK AND COVER DESIGN: Patricia Evangelista

Page 2–3: Hong Kong goes international: Maggie Cheung in Paris in Oliver Assayas' *Irma Vep*.
Page 4: Detail of an animation cell from *Weather Report Girl*, based on the *manga* by Tetsu Adachi.

Distributed in Canada by Raincoast Books
8680 Cambie Street
Vancouver, British Columbia V6P 6M9

10 9 8 7 6 5 4 3 2 1

Chronicle Books
85 Second Street
San Francisco, California 94105

www.chroniclebooks.com

000038611
Luton Sixth Form College
Library
791.43095

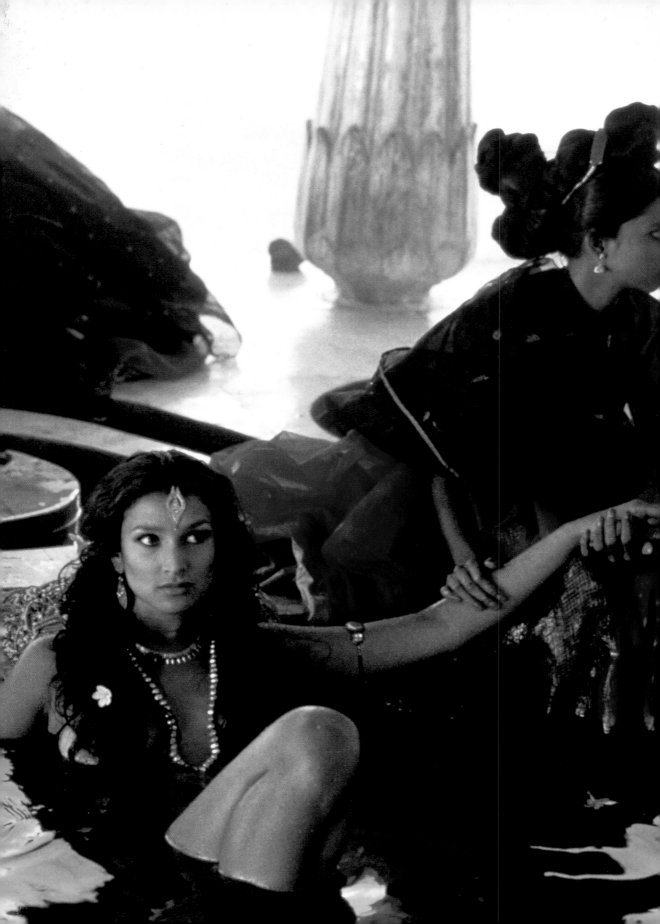

INTRODUCTION:
ONCE UPON A
TIME IN THE EAST

FOR A WESTERNER, Asian cinema has been a kind of El Dorado, full of unmined treasures, more myth than visible reality. The official big-screen importers of the past—of Kurosawa and Satyajit Ray, Filipino women-in-prison sagas and Shaw Bros. chop-sockys—never did more than skim the surface. The rest . . . tantalizingly unavailable. Xenophobia, audience indifference, producers' paranoia: who knows why so few films ever made it across the Pacific? Of 500-plus *yakuza* (gangster) movies produced in Japan in the 1960s and '70s—including such deliriously entertaining examples of the genre as *Tokyo Drifter* and *Graveyard of Honor and Humanity*—exactly one, the rather ordinary *Tattooed Hitman*, achieved a big-screen run in the United States. Americans continue to suffer such deprivations. Jackie Chan, the world's most popular film star, went for more than a decade without a major U.S. release for any of his amazing crowd pleasers. The much-acclaimed *Sonatine* by Takeshi Kitano sat on an American distributor's shelf for years. And these are the international hits and award winners. The opportunities for more esoteric fare have been largely nonexistent.

Videotape has improved the situation, to be sure. One can now possess more film history than at any time since Edison could fit the whole thing into his broom closet. Smaller, more adventurous video companies make available foreign titles that would have previously played a few days in a major metropolis and then disappeared. But even these resources are limited and generally narrow-focused on the rarefied art film, and the more genteel subdivision at that. Only

Opposite: A scene from Mira Nair's erotic extravaganza, *Kama Sutra*. Right: Japan's Shintaro Katsu as the lovable and lethal blind swordsman, Zatoichi.

the wonderfully entertaining movies of the Hong Kong renaissance have been truly well-represented in commercial channels, this thanks largely to the efforts of a single company, and the thoroughly remarkable explosion of interest in Hong Kong cinema—an exception, so far, to the rule.

To view the full—or at least a considerably wider—range of filmmaking in Asia, then, one must venture beyond the mainstream marketplace, on to the bijous and grindhouses of the countries of origin (but hurry, some nations have shuttered most of their theaters and all but abandoned local production for Hollywood imports); to ethnic video stores in assorted Chinatowns and the newer immigrant centers renting imported tapes from the old homeland; to the dicey world of intrepid mail-order entrepreneurs and their black-market dubs, which offer a more uninhibited selection of the same (*caveat emptor,* chum, viewing some bootlegs is like watching a movie through an old shower curtain); to any of the world's 300-and-counting film festivals, particularly Ruritanian venues sponsored by cognac makers and experimental drug companies, thriving forums for the obscure, the forgotten, and the next big thing. Admittedly, this is a more exhausting regimen than a drive to the local Blockbuster, but only then can you begin to taste the flavor of Eastern cinema at its richest.

The effort, my friend, is worth it—accessing a treasure trove of fascinating filmmaking, movies never released in the U.S., some never officially released anywhere: legendary titles, obscure works by major directors, exotic exploitation movies, imposing creations by unheralded new talents. The sensation will be a little akin, I imagine, to that of French cinephiles after World War II, seeing all at once the lost years of Hollywood product: film noir, MGM musicals, Tex Avery, the works. Only here it is the more daunting experience of discovering the efforts of many decades and numerous nations. Feast your eyes on King Hu costume epics from Hong Kong; the insane genre transgressions of Korea's Kim Ki-Young and Japan's Seijun Suzuki; the Philippines' erotic *bombas;* masterpieces from Hideo Gosha and Jang Sun-Woo; vehicles for the charismatic Brigitte Lin, Ken Takakura, Rosanna Roces, and Karisma Kapoor; the oneiric thrillers of Sogo Ishii; the world of Thailand's princely auteur of the gutter; the unbelievable *Rapeman* series; Bollywood musical mysteries; cyberpunk animation; and more, much more!

Right: Kaneko Ken in Takeshi Kitano's *Kids Return.* Left: One of the delinquents turned pugilist in Kitano's *Kids Return.*

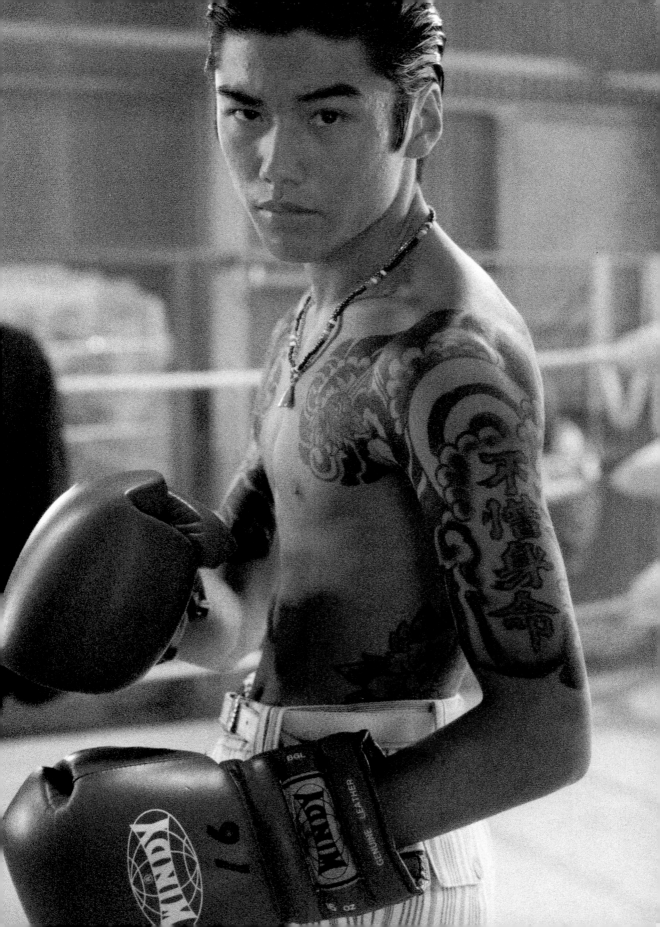

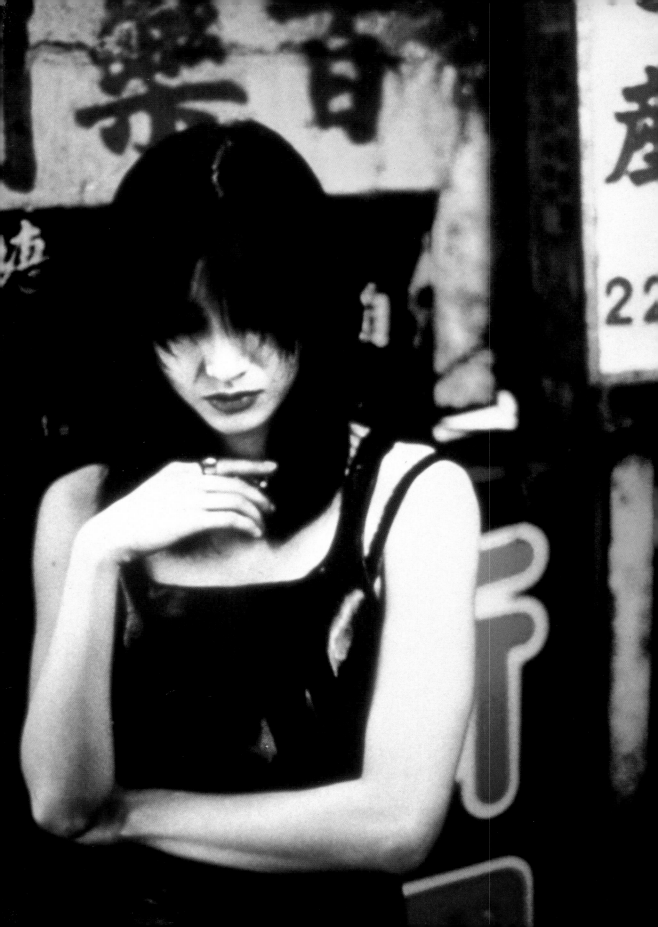

HONG KONG

ON JULY 1, 1997, rule over the former British colony of Hong Kong was assumed by the government of mainland China, and film fanatics around the world suffered a collective anxiety attack. On that day a rigid and censorious regime became overseer of the planet's most uninhibited and anarchic film center, birthplace of *The Killer, The Bride with White Hair, Savior of the Soul, Dr. Lamb,* and other pop classics, and there was not a thing the distressed cinephile could do to stop it.

As it happened, the historic transfer of power occurred with no reports of mainland troops summarily rounding up bosomy starlets or seizing the studio arsenals that armed countless thousands of cinematic miscreants. Nonetheless there remained a strong sense that the free-spirited creative revolution that had begun a dozen or eighteen years before (depending on your choice of touchstone production) had come to an end. The artistic community was already disrupted and dispersed, many stars, directors, and key personnel had gone to more salubrious locales, and even the most optimistic of those who stayed behind believed things could never be exactly the same. Film fans waited and wondered: was the future of Hong Kong cinema to be one of peasant tragedies and moral lessons, Beijing-approved art-house still lifes? Too soon to tell. All that could be said for sure was that if the decade-plus roller coaster of Hong Kong pop filmmaking was indeed now over, it was a thrill ride that would not soon be forgotten.

From Wong Kar Wai's *Fallen Angels.*

A MOVIE BUSINESS had thrived in Hong Kong since the silent era, though in prewar days it was a modest competitor to Shanghai, the Chinese Hollywood. After the Communist takeover, many of the Shanghai pros fled to Hong Kong, resuming their work on the sort of sentimental melodramas of which Mao would not approve. Modestly budgeted black-and-white kung fu movies and just plain modest love stories were produced for local audiences for many years, until the brothers Shaw took the HK movie business into the modern world with color and widescreen—magnificent "Shawscope"—and more aggressive marketing techniques (like the predivested Hollywood studios, they owned their own chain of theaters). The Shaws found their greatest success and spe-

 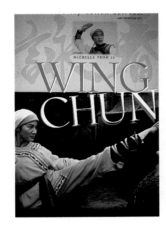

cialization in the period action film—formulaic exercises for the most part, with their repeated use of stock plots and character types and familiar standing sets at the Clearwater Bay studio. As their American soulmates the Warner siblings once did, the Shaws ran their operation along penitentiary lines. Salaries were kept at a pathetically low scale, even for some popular stars, and it was said that staffers had to sleep at a studio dormitory, to get more work hours out of them and keep a strict eye on 'em besides. John Woo, apprenticing at Shaw Bros., recalled, "They didn't like a lot of outsiders."

Shaw Bros. productions were the state-of-the-art in movie violence and the fight choreography grew increasingly elaborate. But the surface dazzle was undercut by mundane acting, interchangeable scripts, and generally primitive technique, most lamentably a cheapie over-reliance on crude zooms. Few of the contract directors had anything like the kinetic snap and subtextual imagination of the Shaws' talented workhorse, Chang Cheh, the Don Siegel/Sergio Leone of '60s–'70s kung fu. The best of his dozens of wild action films, *Vengeance*, *The One-Armed Swordsman*, *The Five Venoms*, and *The Boxer from Shantung* among them, were demented pulp

Left to right: Tsui Hark's sci-fi noir, *Wicked City*, live action adaptation of a Japanese *manga*; martial arts action with a female perspective: Michelle Yeoh in *Wing Chun*; Chow Yun Fat starred in *Full Contact*, Ringo Lam's hardboiled pulp masterpiece; poster for the magnificent HK fantasy *The Bride with White Hair*, starring Brigitte Lin.

Brigitte Lin Ching Hsia
Leslie Cheung [star of *Farewell My Concubine*]

Bride with White Hair

©1993 MANDARIN FILMS PRODUCTION. ALL RIGHTS RESERVED. ARTWORK ©1996 TAI SENG VIDEO MARKETING. ALL RIGHTS RESERVED.

classics, characterized by a cool stylization and relentless inventiveness. His delineation of brotherhood and heroic sacrifice would have an enormous influence on one of his young assistants and admirers, the aforementioned Mr. Woo.

The first Hong Kong movie to find a worldwide audience was a product of the Shaw Bros. kung fu factory, *Five Fingers of Death* (aka *King Boxer*), starring Lo Lieh, in 1972. On American screens, where it played with great success, the film seemed to fill the niche for primitive, anti-Hollywood nihilism recently left vacant by the dying spaghetti western genre. The success of *Five Fingers* paved the way for the much-ridiculed chop-socky era with, in the U.S., countless atrociously dubbed and seemingly interchangeable movies dumped on urban grindhouses and Saturday afternoon local television in the late '70s and early '80s.

The Shaw Bros.' skinflint attitude toward talent caused them to lose kung fu cinema's once and future god, Bruce Lee. After a peripatetic time in Hollywood, most notably as Kato in the *Green Hornet* network series, Lee returned to Hong Kong in search of a starring vehicle, hoping for a hit in exile like Clint Eastwood had had in Italy with his *Dollars* trilogy. When the Shaws offered him too little, Bruce struck a deal with one of their former producers, now a renegade rival, Raymond Chow and his new Golden Harvest studio. The Bruce Lee story has been told, filmed, and retold, so let us do no more than state that his dynamic star presence and agro fighting style electrified cinemagoers the world over and that he reinvented the parochial martial arts movie in his own edgy yet hypercool contemporary image. He completed four films, and then he died. Producers scrambled to field a successor, some hoping to evoke the Dragon's box office with crassly sound-alike and look-alike discoveries—Bruce Li, Bruce Lei, Dragon Lee. At least one of the would-be Lees, a young Jackie Chan, was forced to play grim tough guys against his natural good-humored ebullience, stalling his own bid for superstardom.

In the wake of the Bruce Lee phenomenon, numerous small production companies sprang up to challenge the Shaws and Golden Harvest for the martial arts audience. For aficionados the inundation was a golden age, though by the late '70s general audiences had grown bored with the endless stream of Shaw costumers and "fists and feet" retreads. The Shaw Bros. decided to cut and run and stopped making movies altogether—the kung fus, the supernatural costumers, the revolting horrors—putting twenty years of exuberant pop art on mothballs, and devoting all their resources to television production.

Oddly, just as the old pros the Shaws were turning to the small screen, so were a group of much more adventurous young talents. The economic success of Hong Kong had fostered a growing cosmopolitan class, including hip young film buffs, some of whom had attended film schools in Europe and America. They came back to Hong Kong filled with ambition and—by Hong Kong standards—radical ideas about moviemaking. "I was one of those people who worked in television coming back from somewhere else with a university education," said Tsui Hark, the single most important figure in the Hong Kong cinema renaissance to come. "Pretty soon television became a very fantastic phenomenon. People turn on the television and they see unusual stuff. Sometimes it works, sometimes it doesn't work." In 1978 Tsui directed an acclaimed TV miniseries, *The Gold Dagger Romance*. It led to big-screen opportunities. "At the end of the '70s there was a decline in the movie industry in Hong Kong, so the movie industry went looking for new

blood," he told *Giant Robot* magazine. "In three or four years this group of people was called New Wave." Members included Ann Hui, whose *Boat People* was an international festival favorite, Clarence Fok, Kirk Wong, and Stanley Kwan, all bringing contemporary and innovative elements to HK cinema in the same period.

Tsui's first feature was *The Butterfly Murders* in 1978, a "science fiction film about butterflies that kill people." In Hong Kong at the time there was no such thing as a modern special effects department. When he wanted to film a scene with thousands of butterflies, Tsui had no alternative but to corral thousands of butterflies and hope they would turn in an award-winning performance. "Twenty thousand butterflies flying around, and the people are catching the butterflies after every take!" Wasteful of time, pathetic, Tsui thought. Inquiring of more seasoned local filmmakers why they had no facilities for up-to-date visual effects, he was told "that's for Hollywood, not for us"—a red flag to an artist as ambitious and imaginative as Tsui Hark.

He set about recruiting design and technology students, and bringing in specialists from America, creating Hong Kong's first miniature departments, blue screens, everything. Result: *Zu: Warriors from the Magic Mountain,* a dazzling special effects–laden fantasy adventure, Chinese mythology as sword and sorcery epic, a smash hit.

While Tsui sought technical parity with Hollywood, he felt no particular need to imitate Hollywood content. His vision of a popular modern Hong Kong cinema would encompass ancient folklore and myth, remakes of the swordplay and martial arts adventures he enjoyed as a child, contemporary crime and love stories, *manga*-derived horror and science fiction, and strange hybrids of the above. Establishing his own studio, Film Workshop, Tsui, in addition to directing his own projects, became producer/overseer for other new film talents and forgotten or misused veterans like King Hu and John Woo (an inveterate meddler, in his creative frenzy, Tsui Hark had clashes with these more visionary directors). The Workshop productions poured forth: *A Chinese Ghost Story, Peking Opera Blues,* Woo's *The Killer* and *A Better Tomorrow I* and *II* (and the Tsui Hark-directed *ABT III*), *Swordsman, Dragon Inn, Once upon a Time in China, Once upon a Time in China II, III, IV,* etc.

Tsui Hark's frantically entertaining movies revived ancient genres even as they exploded them. *A Chinese Ghost Story* was a cheesy drive-in horror fairy tale art movie with musical numbers. *Peking Opera Blues* mixed political satire, suspense, farce, theater history, Republic Pictures' serial chases, and cross-dressing. *Once upon a Time in China* (the international release title that echoed Leone's sprawling western and gave critics a ready-made hook) eschewed Tsui's typically chaotic razzle-dazzle for a stately epic, resurrecting real-life nineteenth-century martial arts legend/patriot hero Wong Fei Hung, popular protagonist of hundreds of Hong Kong movies from the 1920s to the 1960s. As with so many of Tsui Hark's releases, *Once upon a Time* sparked a rage, and countless period kung fu movies followed in its wake. With his dominating presence and reflective influence, it was sometimes hard not to think of Tsui Hark as Hong Kong cinema, period.

But Tsui was only the busiest bee in the colony. As the '80s proceeded, Hong Kong began to make films with a breathtaking fecundity. Some said it was the looming uncertainty of 1997, even though a decade and more away, that sparked so much intense production, though the healthy response at the box office couldn't have hurt. The young university-trained cinephiles

and the vets from the school of hard knocks, the gorgeous teen idols and fashion models turned overnight film stars and the seasoned graduates of the Shaw Bros. dormitories, all synergized to produce a popular cinema that soon had no equal for variety and imagination. While other countries found their local film productions dropping off in the face of television and Hollywood, Hong Kong's climbed to record highs. Production schedules were frantic and nonstop. In-demand players might work on half-a-dozen different pictures during a single week, and a hot star might average a new release every month of the year. Hit films sparked trends, instant and constant knockoffs, official and unauthorized sequels.

Fronting this outburst of creative activity was a company of distinctly talented performers, the likes of which, for their glamour and allure and the uniqueness of their personalities, could only be compared to Hollywood in its Golden Age. Triad shoot 'em ups, swordplay epics, adventures of lady cops and hopping vampires, "gambling" stories, slapstick horror, period sex extravaganzas, and Jackie Chan—whose daredevil vehicles were a genre unto themselves. Jackie Chan's

manic optimism makes getting bones broken look like fun. He revels in his mishaps, highlighting them in the reel of "bloopers" run during the end credits, the outtakes of dangerous pratfalls and sudden injuries and the van careening to the hospital like a clip from a Keystone Kops chase. Filming *Armour of God* at a castle in rural Yugoslavia, the actor took a leap from a forty-foot parapet to the branch of an adjacent tree—and missed. His body flew downward through space, slamming into the rocks below. A portion of the right side of his skull imploded and his ears and nose poured blood like an open faucet. Doctors barely managed to save his life. His fractured skull left a permanent crater-like indent at the top of his forehead. "I don't do special effects," he once said. "It's not like Superman, Batman. Everybody can be Superman . . . but nobody can be Jackie Chan!"

Born in Hong Kong in 1954, Jackie as a child was given over by his impoverished parents to the care of the Peking Opera Academy, a performing arts school that had much in common with Oliver Twist's boyhood home. Under these mean circumstances his extraordinary performing skills, agility, and indomitability were forged. He worked steadily in kung fu pictures, doing stuntwork and small roles, playing the punching bag for other actors, including Bruce Lee. After a few false starts Chan got one last shot at stardom, in something called *Snake in the Eagle's Shadow*, about a martial arts student and his disreputable old teacher. In this one Jackie presented himself as the anti-Bruce. The action was still dazzling and intense, with Jackie showing as much

Above: Wong Kar Wai's daring story of two wandering homosexuals, *Happy Together*.

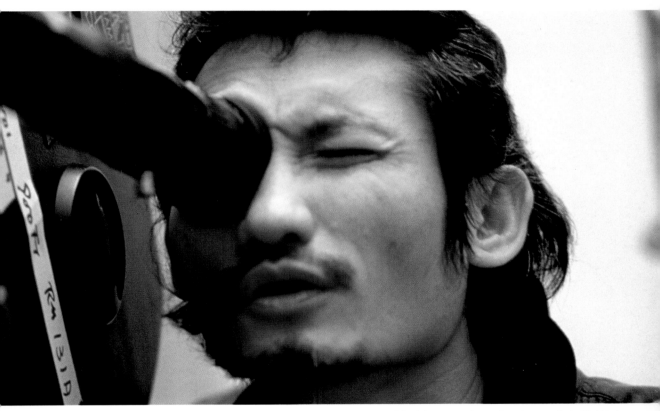

Behind the camera, director/mogul extraordinaire Tsui Hark.

lightning speed and dexterity as Lee, but his scenes caused the audience to laugh and jump in their seats rather than groan and shudder. *Snake* was a hit, and the next one, the exhilarating *Drunken Master,* made him a superstar.

Jackie's good-natured, self-effacing persona, and demystified kung fu films irritated some fans of the genre, but most Asian moviegoers responded enthusiastically to his ingratiating charisma. After a misstep in America, Jackie returned to Hong Kong and began producing a steady stream of huge hit films: *Project A, Wheels on Meals, Operation Condor,* etc., expanding the scope and impact of Hong Kong movies. He shifted the focus of his action films from fights to stunts (though not without plenty of amazing Jackie-style hand-to-hand as well), admitting the influence of the silent screen's athlete-clowns, Buster Keaton and Harold Lloyd. The canvas for the stuntwork grew larger with every film, utilizing planes, trains, motorcycles, wind tunnels, and epic car chases, such as the one that opens *Police Story,* destroying a whole neighborhood in the melee. They were as big as the Hollywood product, but always had that edge: no matter how elaborate the daredevil and action scenes, Jackie never forgot the human factor—his own charismatic presence, front and center, risking life and limb.

The epitome of the new wave of HK stars was Chow Yun Fat, who catapulted to fame playing the hiply tragic Mark Gor in Woo's *A Better Tomorrow,* consolidating his stardom with a long string of dynamic performances in such films as *God of Gamblers, City on Fire, Once a Thief, Prison on Fire, Full Contact,* and the nonlethal *An Autumn's Tale.* He is tall, handsome, with a worldly insouciance, a distinctly contemporary presence compared to his predecessors. His charisma has range: he can be debonair and slyly comic in one film, a haunted noir romantic in the next. He is a Hong Kong action star who did not come out of the martial arts world. Woo's kinetic crime films had made firepower sexy and Chow was the guy who did the shooting. But he wasn't limited to action, another distinction. He could do comedies, love stories, dramas—actually anything *but* kung fu.

His female equivalent, it might be considered, is the entrancing Maggie Cheung, a skilled actress who can go from comic book camping to moving, in-depth performances in the blink of an arc light, all the more extraordinary considering that her move into emoting was from the shallow training grounds of modeling and beauty pageants. She was irresistible as the impudent human serpent sibling in *Green Snake,* and as the ballsy innkeeper in *Dragon Inn.* In the outlandish Batman-like fantasy *The Heroic Trio,* she is an exalted biker chick in black leather. Disappearing from the film scene for a few years, she made a triumphant return in Peter Chan's romantic *Comrades: Almost a Love Story,* charming as an immigrant working at McDonald's, falling into a love affair with an understandably smitten Leon Lai. She gave another engaging performance in the controversial (to the Beijing government, anyway, which reportedly made one reel of film "disappear") true story *The Soong Sisters,* playing one of three siblings, each of whom married a mover and shaker in modern Chinese history; Cheung then went on to France where she was properly fetishized in black catsuit in Oliver Assayas's *Irma Vep.*

Right: The one and only Jackie Chan.

JACKIE CHAN

Warrior, Brother, Protector, Friend

HEART OF DRAGON

TAI SENG VIDEO MARKETING presents A CENTURY PACIFIC ENTERTAINMENT release of A GOLDEN HARVEST production "HEART OF DRAGON" starring JACKIE CHAN | SAMMO HUNG EMILY CHU directed by SAMMO HUNG
©1985 GOLDEN HARVEST (INT'L) LTD. ARTWORK ©1997 TAI SENG VIDEO MARKETING. ALL RIGHTS RESERVED.

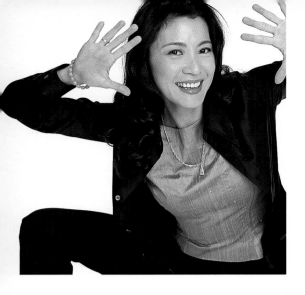

Though Hollywood might have seen the action film as a masculine genre, Hong Kong was audaciously nonchauvinistic, an equal opportunity employer when it came to on-screen derring-do and blood-letting. Moon Lee (of the *Angel* series, for starters), Yukari Oshima (aka Cynthia Luster), Cynthia Khan (star of the *In the Line of Fire* series), and Jade Leung (ferocious assassin in *La Femme Nikita* ripoff *Black Cat* and its sequel—she was horribly burned in a fire-bomb accident shooting *Enemy Shadow*) were some of the top names among Hong Kong's numerous fighting females.

Arguably the most talented and appealing of them all was Michelle Yeoh (aka Khan), a Malaysian-born former dancer who became a top star after playing the fearless police-woman in *Yes Madam,* doing most of her own risky stunts, including crashing through real glass. She took an early retirement after marrying movie mogul Dickson Poon, who did not want his wife coming home from work covered in stitches. When the marriage dissolved, she returned to movies, becoming bigger than ever. As the stoic mainland law enforcer in *Supercop* she very nearly stole the picture from the irrepressible Jackie Chan—talk about an impossible stunt. She then played a martial arts innovator in *Wing Chun,* a period kung fu adventure loosely based on histor-ical fact. Charming and funny even when she's ripping off a bandit chief's genitals, Yeoh's training as a ballet dancer is evident in her gracefully stylized fight scenes. Director Ann Hui's *Ah Kam* gave her a chance to continue showing off her athletic skill and enact a more naturalistic contemporary characterization, playing a stunt woman in—what else—the rough and tumble world of HK moviemaking (and nearly breaking her back in a jump from a bridge). Like many of her peers, Yeoh moved into international productions, in her case nabbing a showy role in the James Bond movie *Tomorrow Never Dies.*

A kind of warped funhouse mirror reflection of Hong Kong cinema's noble heroes were the antisocial and nihilistic roles played with daring brilliance by Simon Yam, the Chinese Robert DeNiro. In supporting roles—the effeminate sadist gang leader in *Full Contact,* the super-suave Vietnam liaison in *Bullet in the Head*—he steals the movies in a walk, while his leads—the slice 'n' dice serial killer in *Dr. Lamb,* the crack-smoking cop in *Day Without Policeman,*

Above: Michelle Yeoh. Photo by Robin Holland. Right: Poster for *Gunmen:* a stylish, small-scale action film about cops and gangsters in prewar Shanghai.

the psycho stalker in *Insanity*, the stud hired to seduce a lesbian in *Gigolo and Whore*, among them—are colorful, uncompromising incarnations of the dysfunctional and the depraved.

"More stars than there are in the heavens," they once said of MGM, and in the '80s and '90s Hong Kong could take the motto as its own, with a roster that included Garbo-like enigmatic beauty Brigitte Lin (*Swordsman II, East Is Red, Chungking Express*); wiseguy comic and box office record-breaker Stephen Chow (*Fight Back to School, God of Cookery, From Beijing with Love*); Jet Li (*Once Upon a Time in China, Fist of Legend*), the *wu shu* champion who became the first modern Hong Kong star to come out of the mainland film world; stunning Chingmy Yau, Leslie Cheung, Anita Yuen, Anthony Wong, Takeshi Kaneshiro, Carrie Ng; "Category III" beauties Amy Yip and Pauline Chan, and so on.

WITH ITS INCREASINGLY varied and satisfying product, the Hong Kong film industry found its audience expanding by leaps and bounds, reaching from the crowded colony to the rest of free market Asia, to a worldwide Chinatown circuit, and finally to adventurous Western film buffs. In Europe and North America, the arrival of home video in the '80s put tapes—from immigrant mom-and-pop video stores to fanzine-advertised bootlegged dubs originating who knew where—into the hands of the vanguard cultists who sang the praises of this exotic and over-the-top cinema. General Asian audiences appreciated the satisfying eye candy Hong Kong was churning out, the

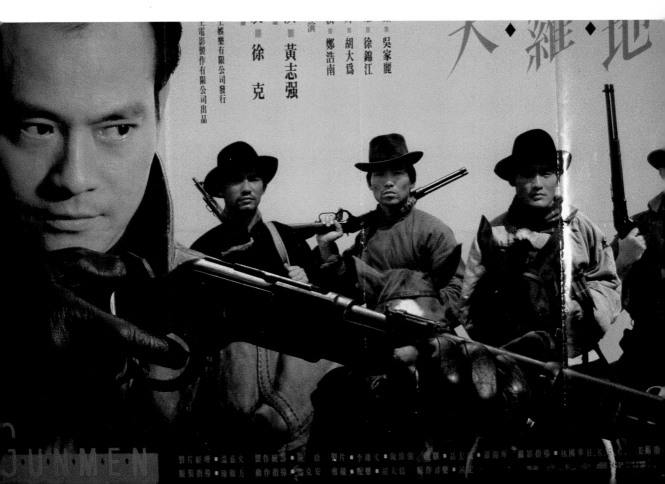

chance to laugh, bounce in their seats, cry. The cultists were gripped by the dangerous, rule-breaking filmmaking. Fans fixated on the films' lurid excesses, dizzying thrill-rides, and the happy-go-lucky nihilism of stars doing their own stunts and losing pieces of their skulls for their art. As a leading lady is engulfed in out-of-control flames, the director keeps filming and puts the accident in the movie. Other stars and stuntmen are mangled, burned, and beaten, but not defeated; the show must go on! Chow Yun Fat speaks—admiringly—of his director John Woo: "Out of control! Out of his mind!"

Hollywood looked like a stodgy old man in the face of this pop cult wildness, a geezer staring at computer screens and looking over his shoulder at market researchers and protest groups. In Hong Kong they weren't making movies for insurance companies or Sunday School scolds. No one was telling these guys that something was too unbelievable, unmotivated,

outré, that it tested badly, or that there was such a thing as too much violence. Why shoot one gun when you have two hands? The look of surprise on Chow Yun Fat's face as the grenades go off behind him in *A Better Tomorrow II* is not exactly acting. Says Woo: "His hair was catching fire."

There was the whiff of real danger behind the scenes as well. Not since the hey-day of the Rat Pack had there been such a colorful and direct interconnection between showbiz stars and organized crime. One of Bruce Lee's film mentors was said to be a member in good standing of the notorious Sun Zi On triad. The less than amicable breakup of the auteur and his star and Bruce Lee's "mysterious" sudden death led to speculation that he had been the victim of a triad rubout.

Jackie Chan, too, was rumored to have run afoul of the well-connected when he sought contractual freedom. He supposedly cooled his heels in Taiwan for two years while Raymond Chow of Golden Harvest delicately negotiated for his cinematic future, and his life. Then there was the case of Jet Li: not long after the release of *Once upon a Time in China* he hired a new manager to demand what they saw as appropriate wages for a superstar; said manager, Jim Choi Chi Ming, was then murdered by a gang death squad. Coincidence? No comment.

As the Hong Kong movie business burgeoned and the cash flowed, some local gangsters muscled in on unprotected stars and production companies, demanding and usually getting a piece of the action. Some mobsters in need of a creative outlet became indie producers themselves. When a hot new starlet turned down a triad production, threats of a face-slashing made her reconsider. There were nightclub brawls and shootouts between rival would-be moguls. *Naked Killer* writer-producer Wong Jing ended up in a wheelchair after receiving a beating on the steps of his office. Finally, in 1992, when the film negative for a Stephen Chow comedy, *All's Well Ends Well,* was kidnapped and held for ransom, the moviemakers decided things had gone too far and organized a star-studded demonstration. They demanded increased police protection, freedom from triad extortion, and the arrest of all film critics.

With the amount of colorful violence on (and off) screen, it was easy to overlook the fact that Hong Kong filmmakers produced much more than blood and broken bones (and that some of the most combustible of the action films, particularly Woo's masterworks, had far more depth and complexity than those made elsewhere). Films like Stanley Kwan's *Rouge,* a story of undying love, and Clara Law's charming *Autumn Moon* were among the many quieter but no less satisfying entertainments. Even Jackie Chan could change pace on occasion, as in his pet project *Miracles,* a remake of sorts of Frank Capra's sentimental comedy-drama *Pocketful of Miracles* (which remade Capra's own earlier *Lady for a Day*).

What the resolutely populist Hong Kong films lacked more than anything was the cachet of obfuscation and self-conscious seriousness that would admit them into the highfalutin' circles of international film festivals and America's prim "foreign film" circuit. This lack could be said to have been mitigated by the arrival of HK wunderkind Wong Kar Wai, who, with his idiosyncratic story sense and lyrical play with film grammar—his way of making it all seem new again—constituted a kind of one-man *nouvelle vague.* His first film was 1988's *As Tears Go By,* a quirky love story set in a grubby demimonde of hustlers and debt collectors, starring Maggie Cheung and Andy Lau. His incipient lyricism came full-flower in 1990's *Days of Being Wild,* an homage to *Rebel without a Cause* with a cast of young pop music stars. Declaring that in Hong Kong you made either "a cop, a gangster, or a kung fu film" (not quite true, as the preceding paragraph indicates), Wong Kar Wai proceeded to subvert these industry staples. His kung fu film, *Ashes of Time,* set in an awesome Chinese wilderness, would not have made the Shaw Bros. happy, with its depressed, ambivalent swordsmen and its indulgent languorousness and experimental

Left: Poster for *A Chinese Ghost Story III*, third entry in the popular and influential series, directed by Ching Siu Tung. Above: Wong Kar Wai. Photo by Robin Holland.

photography. Shot during a hiatus in the production of the epic *Ashes, Chungking Express* contained some requisite cops and gangsters but had little else in common with the average HK crime story. Wong's bipartite movie of lonely policemen, kooky counter girls, and fatalistic drug dealers (Brigitte Lin, a haunting noir icon in shades, platinum wig and shiny trenchcoat) had the offhand beauty and bittersweet romanticism of the early Truffaut. *Fallen Angels* was a spiritual sequel to *Chungking,* another lyrical, playful film, a tale of longing, love, and a rueful hit man, in swirling impressionist images by Wong's frequent cinematographer, Australian-born Chris Doyle.

IN THE MID '90s, even as the films of Hong Kong were becoming an established entity in Western pop culture, with numerous titles picked up for mainstream theatrical and video release in Europe and America, and despite the fact that film production continued at an even more hectic pace, there was a sense that the best years were already in the past. The nearing uncertainty of July '97 sent many of the key figures of the HK film renaissance into exile, scattered to other film capitals. Hong Kong audiences were showing less interest in the local product, and box office returns were way down from previous years. Some said the boom in production had brought in too many mediocre talents and led to too high a percentage of lousy movies. Local media pondered the

"death" of the HK movie industry. And among the Western devotees a large number confined their interest to that first wave of action classics by Woo, Chan, and their peers.

However, the aura of decline was belied by the facts, as satisfying and innovative works continued to be made. The crime film, a staple for over a decade, was reinvigorated with *Young and Dangerous* (adapted from the *manga, Teddy Boy*), the first in what would be an instant subgenre of "triad punk" movies. Seductively oozing cool, *Young and Dangerous* showed a group of photogenic junior gangsters killing, dying, and fighting boredom in between. Two months later came *Young and Dangerous 2,* more of the same with Taiwanese mob politics thrown into the mix and the delectable presence of Chingmy Yau as a gangster's moll; in another ninety days there was *Y&D 3.* Andrew Lau directed each with electric tension, his nervous Steadicam ever on the prowl through the garish fluorescent landscape of the big city at night. The immediate knockoffs—*Sexy and Dangerous, Street Angels,* etc.—were not as good as the first films in the cycle, but one, *Once upon a Time in Triad Society,* was even better, a complex exploration of the allure and consequences of crime, with a dazzling performance from head bad guy Francis Ng. The kind of exhilarating creativity that put Hong Kong on the map was well in evidence in director Wai Ka Fai's *Too Many Ways to Be No. 1,* released in early '97, a *Pulp Fiction*-influenced bit of black-humored gangster craziness, so chaotic at times that blood literally splashes onto the camera lens.

Many films evidenced the increased cosmopolitanism of moviemakers and audiences in colonial Hong Kong's last days. Peter Chan's *Who's the Woman, Who's the Man* (the sequel to the hit *He's a Woman, She's a Man*), released late in '96, was an ambisexual gender-bending romp. It was a world away from the typical glum, stately dramas now being approved in mainland China. And what would Beijing make of a film like *A Queer Story,* a serious and sympathetic account of contemporary homosexuals? Wong Kar Wai's *Happy Together,* an altogether racier gay-themed film, with its startling sex scenes involving two major HK male stars, was being made even as the transfer of power was underway, but Wong had shot the bulk of his daring film in faraway Buenos Aires.

As other big names in the business packed their bags, Tsui Hark, one of the great figureheads of Hong Kong filmmaking, professed his determination to remain in place (even while hedging his bet by answering the siren call of Jean Claude Van Damme and setting the latest in the *Once upon a Time* series in America). Certainly Tsui seemed the best equipped to deal with the creative challenges ahead. A recent work like *The Blade* again showed his ability to mine the past without looking back, as he partly remade the Shaws' *One-Armed Swordsman* in an infinitely more sumptuous style and complete with the trendiest *Ashes of Time*-like camera effects. Tsui's film, containing wild action scenes and a dizzying climax, seemed to be presented as evidence that if in the future China's repressive watchdogs would only stand for pure, old-fashioned entertainment, then this was how good it could be.

Left: Leslie Cheung and Tony Leung in Wong Kar Wai's *Happy Together.* Right: Director Yim Ho's *The Day the Sun Turned Cold,* a fascinating Chinese film noir.

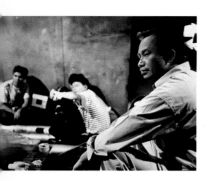

JOHN Woo

JOHN WOO, GOD OF ACTION: his crime and adventure films of the '80s revitalized genre film-making; not just in Hong Kong but around the world. The movies *A Better Tomorrow I & II, The Killer, A Bullet in the Head,* and *Hard-boiled,* are overpowering pop masterpieces of violent cinematic frenzy. But Woo has always been more than just a deity of dynamic screen bloodshed. Like Kurosawa, Peckinpah, Fuller, and Huston, his best work is concerned with deeper issues than the creation of thrilling action and super-cool screen heroes. Left to his own muse, Woo makes films about loyalty, love, tricky human nature, freedom. Of course, the fact that he can film a gunfight in a way that leaves an audience gasping for breath is not to be taken lightly, either. The acclaim Woo's HK films received brought the director to the attention of the American studios. The U.S. phase of his career began with the underrated Van Damme actioner *Hard Target,* followed by *Broken Arrow* and the extraordinary *Face/Off,* two smash hits that put Woo at the top of Hollywood's A-list, where he now resides.

Above: Action director John Woo in Hong Kong.

JOHN, CAN YOU TELL ME A LITTLE ABOUT YOUR LIFE AS A CHILD, AND WHAT IMPACT THE MOVIES HAD ON YOU THEN?

Lee, when I was a kid in the slums I always felt like I lived in hell. I dreamed a lot. Always dreaming of flying away from hell. To go to another, better place, a place with no violence, no hatred, no crime, and where the people all care for each other. And I always felt lonely. I had to deal with the gangs every day. It was hard to get close friends. But when my mom took me to the theater, everything would seem okay. I would find my dreams in the movies, especially the musicals. There was no violence, everything was so pretty. My other favorites were the Westerns. John Wayne, Randolph Scott, Gary Cooper. I saw the hero, fighting for justice, helping people. So these movies gave me a lot of comfort and hope.

After the Communists took over China, Hong Kong was crowded with people, refugees, all very poor, all pushed together, nowhere to go.

WHY DO YOU THINK YOU WERE NOT DRAWN INTO THE GANG LIFE, THE CRIMINAL LIFE THAT WAS ALL AROUND YOU?

I had great parents. They taught me right from wrong. And they had great dignity. And also the Church was a great influence. Whenever I got upset or afraid I would go to the church; that was my shelter, I could find peace there. And we were helped very much by an American family that sent us money.

A classic Wooian pose from *Hard-boiled*.

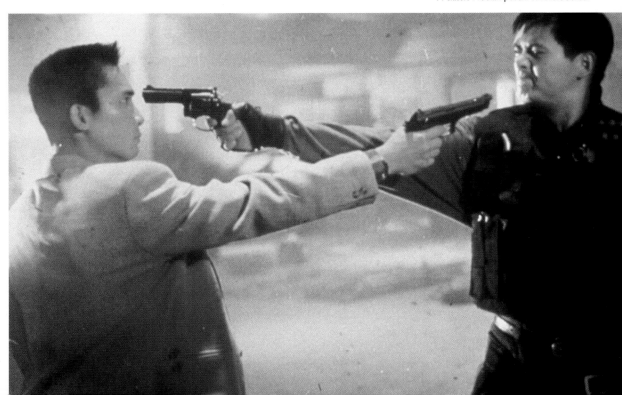

WHERE DID YOU MEET THE AMERICAN FAMILY?
No, we didn't meet. They didn't know us.

IT WAS THROUGH A CHARITY?
Yes. We communicated through letters. I never met them. Later I tried to find them to tell them what they meant to me but the contacts were all lost. So I try to pay them back in the same way, by helping some children in other countries, as the American family helped me.

WHEN DID YOU FIRST THINK THAT YOU WOULD TRY TO ENTER THE MOVIE WORLD YOURSELF?
In the '60s there was a group of us very interested in everything about the movies. We tried to see the films by interesting directors, artistic films, the French New Wave, films by Stanley Kubrick, Alfred Hitchcock. There was an art theater as well as the commercial theaters. We didn't have a film school, but this was like a film school, to go to all these movies every week. I wanted to work in movies but it was not easy to get a job in Hong Kong. Very hard. They didn't like a lot of outsiders. They were a family business and you really had to be related to someone to work in movies. So I was very happy to find a job at the studio. But it was disappointing because everything was so corrupt. People cheating. They didn't care about the movies, they just cared how much money they could get into their pockets. I tried to stay away from them. There were some very good film people there as well, and I tried to work with them.

YOU BECAME A REGULAR PART OF CHANG CHEH'S PRODUCTION TEAM AT SHAW BROS.
Yes. He was a great man. And a big star in Hong Kong—equal to Kurosawa in Japan. He was a very knowledgeable man and he liked to work with young people. Always giving young people a chance. And one time I was almost going to go into acting, because I had done some work in the theater, and these people offered me a role. And Chang Cheh said, "No, John should concentrate on being a director. He will be a good director."

VERY INSIGHTFUL.
Yeah, he had a lot of insight. Very smart. But at the same time he had such a temper. Always losing his temper. He was a screamer. He didn't scream at me, he was always polite to me. But he screamed at the actors. Such screaming.

Yeah, too violent! That's what the censors said. It was a kung fu film, but very romantic, with a love story! I was so upset. I thought the movie was well made. It was done for a small company.

DID THE CENSORS OBJECT TO ANYTHING IN PARTICULAR?

Yeah. I had a scene where the character wears a glove with nails on it, and when he punches someone the nails go into the skin. The censor said that young people would try and copy that. So they banned the film. Later I heard that they were just looking for a bribe. Anyway, we showed the movie to Golden Harvest, all the bosses, Raymond Chow, everybody, and they loved it. They gave me a three-year contract right away.

YOU DIRECTED JACKIE CHAN IN ONE OF HIS FIRST FILMS, *HANDS OF DEATH*.

Actually Jackie Chan was a stunt coordinator for my first film, *Young Dragons*. He choreographed the action with me. He was feeling so down in those days. He wanted to be an actor and he hadn't made it. In those days Hong Kong had a very traditional attitude. The stars had to be very, very handsome. Then in 1975 I was making a cooperative movie in Korea. You were supposed to use half Hong Kong people and half Korean people, but then I got to Korea and I found one of the stars wasn't that good, he was too old and he couldn't fight. And I liked Jackie Chan so much. I liked his energy and his humor. I always truly believed that he would become a star. So I canceled the Korean actor and I gave Jackie the role and I changed the whole script to focus more on him and show his great skill. And afterward I told the studio, "I tell you, Jackie Chan is going to be a very big star." And I was right. I was so happy for him.

DID HE HAVE A LOT OF IDEAS FOR STUNTS, EVEN THEN?

Oh, you know, he almost got killed on that movie we made. He was doing his own stunts and he was a stunt double as well. And there was a scene where he gets kicked by the hero and goes into the air. I needed a shot with much stronger impact, when the hero kicks him. We were using a cable to drag Jackie back. We had six people pulling the cable. We did it seven times and on the seventh take the people dragged him too hard and he fell backwards and the back of his head hit a rock. The rock had a sharp point like a blade and it was sticking one inch into his head. He lost consciousness. And we were all around, we slap him, try to wake him up. And after he woke up he was crying, he didn't know where he was,

and he didn't even know his name. So we all gathered round and we hug him, so glad he came back. I was so glad he had great success later and it didn't end with this accident on our movie!

HAVE YOU TWO REMAINED FRIENDS?

Oh yes. I admire him so much. But it is hard for me when I see his films, the stunts he does. Everyone else is enjoying it but I am thinking of everything that could go wrong!

YOU HAD BEEN AWAY FROM HONG KONG FOR A WHILE WHEN YOU CAME TO DO *A BETTER TOMORROW*.

Yes. I was in Taiwan making films for a long time before I came back.

YOU'VE SAID THAT IT SEEMED CHANGED WHEN YOU GOT BACK.

The people, especially young people, seemed not to care about anything. It seemed like things had gotten to a very bad place. It felt like people were losing any feeling of values, of morality. Everywhere were

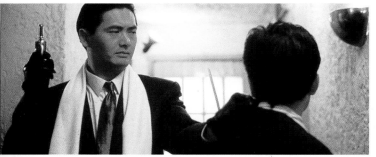

Chow Yun Fat as the dapper hit man with a heart in John Woo's *The Killer*.

people speaking dirty language, with no feeling about life, about other people. I began to think about a story that would be about older values, friendship, loyalty, family. I wanted to make a movie that would show what we had lost, what we had to bring back. And I thought for some time about a character, a hero, someone who could represent the old values. A sense of chivalry. And then as I developed this gangster story, I wanted to show my hatred for dictatorships. These gangsters ruled like dictatorships, the same as some countries. So I had a political feeling I wanted to express as well.

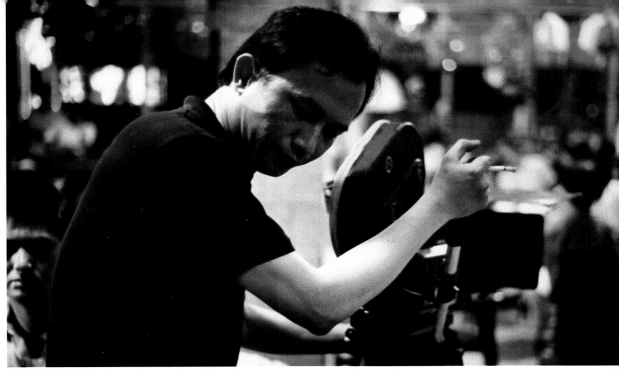

Above: John Woo filming *Hard-boiled*. Visible on the lower left, Chow Yun Fat.

He had been acting in different things. I had seen him in one movie where he played a kind of retired killer and I liked him. And then I found out some things about him, that he always helped a lot of people. That he cared about people in his private life, that he helped his friends. And the more I heard the more I thought he was very much the same as my hero in the story. And as an actor he was perfect. He reminded me of all my own personal idols from the movies—Alain Delon, Gary Cooper, Ken Takakura, Cary Grant, Steve McQueen. There was something from all of them in this one man! And then we talked and I found we had a lot in common. He was a little old-fashioned, liked many things that had been in the old days. I was very excited, I had found the hero for my movie.

Yeah. Ha! And you know Hong Kong has a kind of tropical weather, very warm, and you never need to wear that kind of heavy raincoat. But I liked for him to wear it in the movie. It looked something like Alain Delon's in *Le Samourai*. And after the movie all the young people were buying the coat and the Ray-Ban sunglasses. After one week all of those sunglasses were sold out in all Hong Kong. The people wearing raincoats had to be very hot.

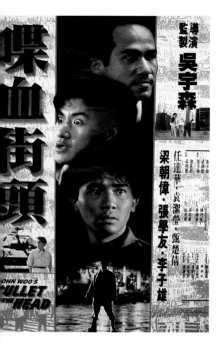

Yes, there was a kind of rush. The first cut was too long, over three hours. And the studio wanted to release only two hours, so we had to cut a lot. And there was so little time that it was being edited by five different people. And I never got a chance to take a look at the whole movie before showing it to the public. So I only saw it in a theater, I was so late. And there were some things that I liked that had been left out, some funny things, and I found the editing wasn't really completed, the style was a little rough. So there are only pieces of it I really like. Even *A Better Tomorrow* was not really complete. Only Chow Yun Fat's character was outstanding. The other characters were still pretty much like soap opera characters. Only with *The Killer* did I get everything as I wanted: every character, the cinematography, the editing were all complete, all in one tone. It's very hard to keep control and to maintain the vision you have for a movie. Because nobody, the actors, the producers, really knows what the movie is going to be like before it is put together. Only after I finished the whole movie and the producers and everybody watched it, then they find out: "Oh, the movie is so romantic." It really surprised everybody.

HOW LONG DID THE FINAL BATTLE IN *A BETTER TOMORROW II* TAKE TO SHOOT?

It was a long time. I think three weeks.

THAT SHOT OF CHOW WHEN HE THROWS THE GRENADE AND HE'S LOOKING AT THE CAMERA WHEN THE EXPLOSION GOES OFF BEHIND HIM . . . IT LOOKS VERY REAL AND HIS EXPRESSION SEEMS ALMOST OUT OF CHARACTER, LIKE HE WAS REALLY STARTLED.

Yeah, he didn't know it would be so strong. And his hair was catching fire.

WHAT INSPIRED THE CONCEPT OF *THE KILLER?*

I was a very big fan of Japanese *yakuza* films, and I had been thinking of one with Ken Takakura that I liked very much [the film is most likely *Narazumo*]. He played a killer, but one with principles. He never killed good people, only those who deserved it. And the killer comes to Hong Kong and he meets a hooker who has TB and he promises to help her. But he gets into a gun battle with the gang and gets killed. And the girl is left waiting because the hero is never coming back. It's a very sad

Left: Poster for *A Bullet in the Head,* Woo's sprawling action drama set in Hong Kong and Vietnam. Right: Poster for an early effort by director John Woo, *Last Hurrah for Chivalry.*

story. And so there were things I wanted to use in that story. And at the same time I thought about trying to remake Jean Pierre Melville's *Le Samourai* or make an homage to *Le Samourai*. So I combined the two stories and made one story.

MANY HONG KONG MOVIE PEOPLE HAD PROBLEMS WITH THE TRIADS. DID THIS EVER HAPPEN TO YOU?

No, not at all. They have never knocked on my door, they have never bothered me. I think a lot of people who had mob trouble were doing business with them, they were already corrupt people. If you let the mobsters know you are straight, they will treat you with respect.

A BULLET IN THE HEAD WAS ORIGINALLY MEANT TO BE ABOUT THE CHARACTERS IN *A BETTER TOMORROW*.

Actually, that film was intended as a prequel to *A Better Tomorrow*. In fact, the first half of the movie is my life story. The producers didn't like the story and so I kept it for myself.

A LOT OF PEOPLE FEEL *A BULLET IN THE HEAD* IS THE GREATEST OF YOUR HONG KONG FILMS, BUT IT DID NOT DO WELL AT THE BOX OFFICE THERE.

Yeah. Looking back I can see lots of reasons. There was no real hero in the movie. And it was very depressing story. The events at Tiananmen Square were a big influence on the film. After the massacre I felt such shock, and was so sad, and I had so much pain about the whole event. I just felt so much anger about what they did to the students. So that made me change the whole story, the whole second half of the story. I began to write something that I intended to be symbolic about the future of Hong Kong. I wanted to show the terror, what it must be like in a war, in a dictatorship. And I think audiences knew what I was doing but it was painful for them to watch. They felt so bad about the massacre, and they didn't want to feel any more pain. And it was not a successful movie, but a lot of people have seen it in America and everywhere and many people seem to appreciate it. It is my most personal movie and I am very proud of it.

YOU SHOT THE WAR SCENES IN THAILAND. A LOT OF THOSE SCENES OF VIOLENCE IN THE STREETS ARE SO INTENSE, SO REAL.

Oh yes, Lee, it felt real when I shot them! I shot about two-thirds of the movie in Thailand and it was like being in a war. I had to create all this violence, these terrible things going on, and it felt very real. The war scenes, the torture. And all this time the massacre, the student getting crushed under the tank, all this kept flashing in my mind. I

was going a little crazy. I felt like it was actual war going on, with people screaming and crying all around me. And I got so crazy, so confused and mad that I ran into the shots in those scenes! And things blew up around me, and I got hurt—something exploded in my face. My face was all bloody. I was screaming and the actors are looking at me. I couldn't control myself. And the ending was very difficult. I didn't know how to end the movie. Oh, I was in such a state of mind!

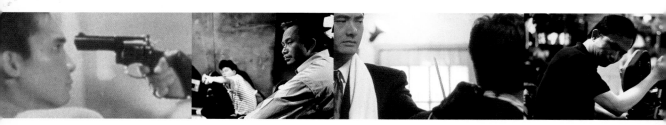

I WONDER IF *HARD-BOILED* WAS A REACTION TO ALL THAT YOU WENT THROUGH WITH *A BULLET IN THE HEAD*. THIS WAS A STORY WITH A REAL OLD-FASHIONED HERO.

Yeah. This was a time when the crime in Hong Kong was almost out of control. The gangsters hired gunmen from China and Philippines to rob the banks. And they were ruthless, using AK-47s, shooting people right on the street. The police force was pretty depressed. The gangsters had much greater firepower than the police! Then I read about something in Japan, a psychopath putting poison in baby food in the supermarket. And you hear this and you get so mad. You read the news and these crazy crimes seemed to be happening everywhere. So I felt I wanted to create a hero who could stand up to these criminals. And I was excited at the idea of setting part of the movie in the hospital. A hospital was a good microcosm of the society, with all those innocent and helpless people inside. And, of course, it had some symbolism for what was soon to happen in 1997: people trapped in a place, hoping that they will survive, and maybe wishing for a savior. And Chow saves the baby, and I wanted the baby to stand for the idea that there was hope, that there was hope for the future.

Left to right: A still from *Hard-boiled;* director John Woo; John Woo's *The Killer;* Woo filming *Hard-boiled.*

NA**K**ED
KILLERS

NO ASPECT OF Hong Kong filmmaking is likely to be so adversely affected by the new mainland rule as that lively corner of the industry devoted to so-called "exploitation." Whatever hands-off policy has been theoretically proposed by the prudes in Beijing, it surely can not encompass the making of movies about lesbian hit teams or unhinged fellows turning human beings into shoes. We have likely seen the end of an era, a dozen-plus years of adults-only entertainment—in Hong Kong labeled as Category III films—that ranged from the titillating to the tasteless to the disturbingly transgressive.

For international audiences, the eye-opening introduction to Hong Kong eroticism was the seminal *Sex and Zen,* based on a Ming Dynasty text with which I confess I am unfamiliar. It is in part the tale of a newlywed with an inferiority complex who has his penis replaced with the more impressive appendage of a horse. The scene of the transplant operation, involving a barrel, an uncooperative stallion, and a hungry dog, sets a mighty high standard for slapstick outrageousness which, nonetheless, the film continually surpasses with its series of bizarre plot complications and an array of comically Kama-Sutric couplings, some of them interspecies.

Starring as the young bride is the legendary Amy Yip, a deadpan beauty whose large breasts were for a time objects of widespread discussion in the Asian press. Dubbed "Miss GB" (for Giant Boobs), Yip was often accused of having undergone enhancement surgery, a charge she heatedly denied. Male friends and co-stars jumped to her defense, proclaiming her chest's

Above: Guns 'n' Dolls: mainstays of Hong Kong exploitation.

authenticity. Previous to *Sex and Zen,* Yip had appeared most prominently—how else—in *Erotic Ghost Story* (1990), a sensuous take-off on Tsui Hark's earlier hit *Chinese Ghost Story.* Amy is one of three sisters who fall prey to the lascivious God of Carnal Desire, a fertility demon, causing the girls to sprout fox hair on their bodies; Yip was the fantasy film's most creditable special effect. Her most notorious part came the same year in *Ghostly Vixen,* playing a succubus who must perform fellatio on 100 virgin boys to obtain her vampiric destiny. Yip had a supporting role, android undercover cop posing as hooker, in the outrageous and fun *Robotrix,* an erotic, gender-reversed variation on *Robocop.* At the height of her controversial reign as Sex Queen of Hong Kong cinema, Yip retired from the screen, apparently finding contentment with a devoted admirer, though she would never disappear from the hearts and minds of her many fans.

Historical erotic romps like the highly successful *Sex and Zen* became a mini-genre for a time. *Sex and the Emperor* was a kind of sordid Cinderella story with lovely Yvonne Yung Hung (winner of the Miss Asia Pacific beauty contest for 1991) playing a comely chambermaid desired by both the naive young emperor and an evil top eunuch. The eunuch conspires with the emperor's fiendish mother to send Yvonne packing to a whorehouse, where she is forced to study and implement the "Ten Semi-Devil Skills" for giving men pleasure (the madame of the house, an advanced student, can hold a brush and paint watercolors with her vagina). The lovelorn emperor tries to find his Cinderella, but unlike the Prince in the fairy tale, this one contracts a fatal case of V.D. Another of Yvonne Yung Hung's awesome Category III epics was the bluntly titled *Chinese Torture Chamber Story,* a mix of spectacle, sadism, and lowbrow humor from the ever-outrageous director-producer Wong Jing. As the plot goes, a Ching Dynasty beauty named Little

Left to right: The remarkably tasteless horror film, *The Untold Story;* startling poster art for *Dr. Lamb,* with Simon Yam as the title character, surrounded by souvenirs; evocative poster for *Red to Kill,* a harrowing suspense shocker about a serial rapist.

Amy Yip, up front, in the erotic comedy of ancient China, *Sex and Zen.*

Cabbage and her scholar lover are falsely accused of murdering her husband with herbs that made his genitals explode. What follows is a zany theater of cruelty piece, a film filled with arcane torture devices, dangerous masturbation practices, and scenes of flying intercourse.

More down-to-earth were the many contemporary erotic films Hong Kong produced, from the sweetly softcore to those—like *Escape from the Brothel* with the enchanting Pauline Chan, *Behind the Pink Door,* another Chan starrer, and *China Dolls,* with the aforementioned Ms. Yip—reeking of sadism and subjugation.

Altogether more charming in its mix of sex and violence was the justifiably legendary *Naked Killer* (script by Wong Jing, direction by Clarence Ford). From its evocative opening title sequence (abstracted images of three knife-wielding females, words projected on bare and writhing back and buttocks) to the explosive, Wagnerian ending, *Naked Killer* is imaginative and cool entertainment of the highest order. Deadly female contract killers stalk the land while Chingmy Yau's hot-tempered Kitty is simply seeking revenge for her father's death when she blows away a couple dozen businessmen. She is saved in her escape by Sister Cindy, an older woman with an exploding hat. Sister Cindy, it seems, is the world's leading female assassin, and after surgically removing Kitty's fingerprints, she tells her she too has the right stuff to become a professional killer. Simon Yam, Hong Kong's master of the artfully sleazy and antiheroic, plays Kitty's temporarily abandoned boyfriend, a traumatized police detective who pukes any time he hears of an act of violence. As Cindy and Kitty begin to ply their trade, they cross paths with a rival set of female killers, Princess and Baby: no one gets out alive. The film's flow of demented and/or stylish sequences never stops: Cindy and Kitty practicing killing in a basement workshop kept stocked with Hong Kong's most wanted rapists and maniacs; the murder of a Japanese gangster in his swimming pool, the nude Baby and Princess making love in shallow water while the dead man's bleeding body floats beside them. Sister Cindy is eventually raped and killed by her rival's hired gang; Kitty avenges her, sending the lethal lesbians to hell, and is reunited with her boyfriend for one last apoc-

alyptic embrace in a gas-filled kitchen, an intensely romantic beau geste; *Romeo and Juliet* by way of *White Heat.*

Hong Kong's notorious docudrama genre got off to a properly grotesque start with the repulsive *Man Behind the Sun,* released in 1990. Supposedly based on WWII-era documents only recently made public, *Man* told the story of Manchu Squadron 731, a Japanese medical torture unit analogous to those run inside Nazi death camps, in this case using Chinese hostages as human guinea pigs. The experiments—arms frozen and shattered like icicles, organ removals on wide-awake patients, etc.—are rendered on film in the most graphic and cold-blooded style. The events deserved to be exposed, but the all too real horrors, dramatized for giddy, gross-out thrills, made the filmmakers seem closer in spirit to the torturers than the victims. A sequel, *Laboratory of the Devil,* continued the historical "exposé."

Tabloid headlines supplied the authentic source for one of Hong Kong's most impressive exploiters, *Dr. Lamb,* directed by actor Danny Lee (costar of *The Killer*) and Billy Tang (a filmmaker with a real feel for depravity). The bad doctor of the title is actually a humble cabbie turned serial killer of prostitutes. Lamb dismembers the bodies, sloppily saving favorite bits and pieces that tend to fall into people's laps at just the wrong moment. It is a film decorated in gore and drenched in more red than a dozen Minnelli musicals. The story is told in a fractured style, flashing back and forth in time with stunning shifts in mood. In one of his signature roles, the ever risk-taking Simon Yam is seen here in his best psychotic, Klaus Kinski-ish mode.

Another shocking real-life crime spree was documented in the stomach-turning horror film *The Untold Story* (with the more telling alternative title of *Human Meat Pies*). It is the case history of a Macao restaurant owner with a bad attitude and a sturdy meat grinder who turns his enemies, real or imagined, into fresh dumplings that he serves to his customers as the Chef's Surprise. The cook's antics are filmed in nauseating detail and with a certain relish, though anyone who has ever worked in a restaurant will probably wonder what's the big deal. Giving Simon Yam a run for his money as the most compelling screen psycho is Anthony Wong, in a role that earned him Hong Kong's highest acting award. This nihilistic movie allows the audience no succor, finding sympathy for the monstrous chef and depicting the police as bumbling clowns whose favorite part of the job is torturing suspects.

Other "torn from the headlines" films followed, but real life couldn't always be depended on to top the lurid imaginings of HK exploitation masters. In the same vein as *Lamb* and *Untold,* though not—we hope and pray—based on facts, was *Horrible High Heels,* about a shoe factory that skins human beings and turns their flesh into footwear, giving the company a surprising boost in sales. Another 1996 release, one that consciously tried to recapture the fetid fun of *Untold Story,* was the breathtakingly tasteless *Ebola Syndrome.* A murderer flees Hong Kong for Africa, where one of his local sexual conquests infects him with the dreaded Ebola virus. Further unhinged, he goes on a raping and killing spree, serving human hamburgers, spitting on people to infect them, and otherwise making a deadly nuisance of himself. As the perfectly awful protagonist, Anthony Wong gives another mesmeric and wayward performance. Likely one of the last of its kind, the horrific, outrageous and goofy *Ebola Syndrome* is a perfect summing-up of the incredibly "sick" side of Category III.

CHINA

FEW FILM SCREENINGS have had the impact of Chen Kaige's *Yellow Earth* when it was first shown before an international audience at the Hong Kong Film Festival in 1985. Mythmakers compare it to the opening night stir created by *The Birth of a Nation* or *Citizen Kane*. Considering that some took the film as a harbinger of significant change in the world's most populous nation, its potential import was considerably greater than those epochal film events—most particularly in Hong Kong, home to the most intense "China watchers." Here was a film like no other to come out of the People's Republic—artful, quirky, studiously aestheticized, and shockingly humane. Set in rural China in 1939, *Yellow Earth* is the story of an earnest, good-natured Communist soldier, wandering the back roads on an odd mission to collect folk songs for his entertainment-starved garrison. He stays for a time with a simple village family, a morose widower and his two children, including a young daughter about to be sold into marriage with an old man. Slowly the outsider and the repressed—if musical—family come to know and like each other, the soldier trying to expand their horizons, telling of possibilities beyond their stifling feudal traditions, filling the head of the young girl with dreams that will, sadly, remain unfulfilled. The film, exquisitely photographed by Zhang Yimou, another name that would soon rocket out of obscurity, had a glowing, burnished beauty, filled with slow-dissolving images of nature, like ancient landscape paintings come to life. Elements that recalled the Chinese propaganda films of the past, such as youth groups and choral songs, were juxtaposed with the free flow of philosophical ponderings and the ambivalent

Red Firecracker, Green Firecracker, director He Ping's film about love blooming at a fireworks factory.

view of the kindly yet destructive father: a mainland film that actually asked the audience to come to its own conclusions.

Was the film a fluke? Did the Beijing government approve? No, to the first question; not exactly, to the second. Censors believed, among other concerns, that *Yellow Earth* had presented a humiliating view of backward village life, even if the setting was clearly nearly a half-century ago, and banned the film for a time before the international acclaim made them rethink their decision. But this was an ominous prelude to the years ahead, as the liberalized climate that had led to the creation of *Yellow Earth* and the films that would follow soon turned hardline once again, the horrors of Tiananmen lying just over the horizon. Films were cut, embargoed, and banned; the directors threatened and barred from using national production facilities. But it was too late to conceal the fact that the government had unwittingly unleashed its second "cultural revolution" in the work of what came to be known as the Fifth Generation.

THE EARLIEST FILMMAKING in China centered around Shanghai, where the large resident international community was much involved. In 1908 an American named Ben Polaski and two Chinese associates created the first large-scale production entity, the Asia Motion Picture Company, followed by the European-based Commercial Press and the first native-run film business, Ming Hsing. The coming of sound and the diversity of dialects within the country encouraged the production of talking movies in other regions, particularly Hong Kong. China's inequities and politicization were reflected in crusading films like *Wild Torrent* and *The Song of the Fishermen*, prize-winner at the 1935 Moscow Film Fest.

Shanghai remained the country's commercial film capital, producing a mix of melodramas, love stories, and other popular fare. Photo stills from the period—all I have seen, alas—show dreamy key-lit studio images, not so different from von Sternberg's shimmering Paramount China. There were Chinese equivalents to Dietrich and her ilk as well, casting their spell—unto death in some cases. Ravishing Shanghai movie star of the '30s Ruan Linyu, just 24 years old, killed herself over a passionate love affair gone wrong. Huge crowds gathered for her funeral while police discovered the bodies of three young fans. "If Ruan Linyu is dead," read their collective suicide note, "what else is there to live for?"

The Japanese controlled the film studios during World War II, and the takeover by Mao in 1949 sent most of what was left of the old capitalist filmmakers into exile. For the most part, moviemaking in China for the next thirty-five years consisted of political propaganda and committee-approved folk tales.

Following the return to power of the previously purged Deng Xiaoping in 1977, many of the old cultural institutions, victims of the Cultural Revolution, were reopened, including the Beijing Film Academy, the country's only film school. The first class of graduates—including Chen Kaige, Zhang Yimou, Li Shaohong, and Tian Zhuangzhuang—became the vanguard of a revolutionary Chinese cinema, eschewing the blatant propaganda of the past in favor of individualized and poetic works of film art. This was China's New Wave, "The Fifth Generation," named for being the supposed fifth class to graduate from the Beijing Academy, though Zhang Yimou has

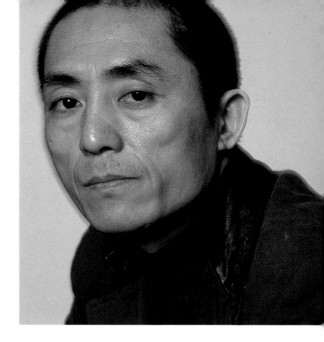

scoffed, "I don't know who the first four were. . . . The Chinese like everything to have a number."

Following on the success of *Yellow Earth,* its cinematographer, Zhang, turned director to make *Red Sorghum,* a stirring drama of peasant life set in the remote northern provinces, climaxing with the invasion from Japan. As expected from *Yellow*'s cameraman, the film was filled with stunning photography of the timeless Chinese countryside, though no glimpse of nature could compare with the beauty of *Sorghum*'s leading lady, Zhang's magnificent discovery, Gong Li. Born in 1966 to a pair of professors, she was a student at the Beijing Central Drama Academy when the director auditioned her and quickly offered her the part. The two became romantically involved and went on to collaborate in a series of extraordinary films: *Ju Dou, Raise the Red Lantern, The Story of Qiu Ju, Shanghai Triad.* The first two explored issues of China's traditional subjugation of women with a pro-feminist slant in tempestuous tales of lust and hatred. In *Ju Dou,* a plush, exotic, and thought-provoking drama with a James M. Cain plot, Gong Li is the young beauty married to a vicious, impotent merchant; she has an affair with his young nephew and ultimately plots the abusive hubby's death. *Raise the Red Lantern* featured Zhang's most narcotic imagery to date in a story of the rivalries among a houseful of concubines. The "blatant" eroticism of Gong Li's foot manipulation gave the censors sufficient cause to ban the film. *Story* was a change of pace for the team: Zhang Yimou as Frank Capra, Gong Li his lovely Mrs. Deeds, a farmer's outraged pregnant wife seeking satisfaction from a sea of faceless bureaucrats, to bitterly funny effect. *Shanghai Triad* was Zhang's version of a crime drama; the story of a prewar Chinese godfather, Mr. Tang, king of the opium and prostitution trades, his beautiful, pampered mistress, and the 14-year-old boy who follows them into exile on a tiny island. In the allegorical way that has ever taunted and confounded China's censor board, Zhang's gangsters seem to allude to the Beijing oppressors (even as his mob boss seems to physically resemble Chiang Kai Shek). Though critics sniffed that the film was slight compared to the previous masterworks, *Shanghai Triad* continued to illustrate the director's visual mastery. Gong Li, as a semitalented and amoral but spectacularly sexy chanteuse, doing her stage act in front of a line of Helen Kane-ish chorines,

Zhang Yimou, director of *Ju Dou* and *Shanghai Triad.* Photo by Robin Holland.

Luton Sixth Form College Library

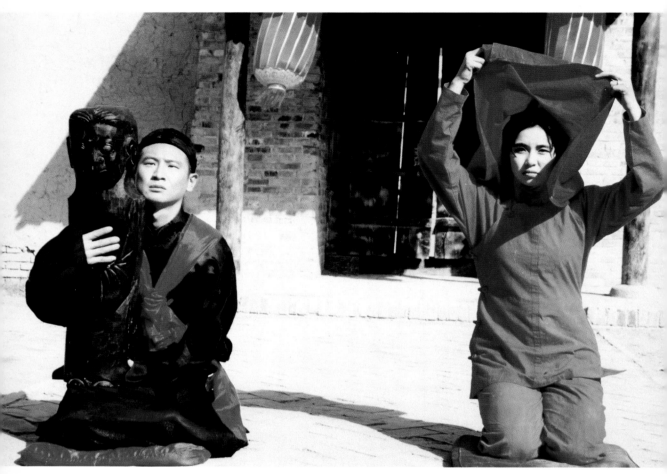

Beautiful Wang Lan meets her mate, a carved statue (in the hands of loyal
servant played by Chang Shih), in *The Wooden Man's Bride*.

was magnificent, out of her peasant duds for a change and wearing a collection of slinky '30s out-fits that would have done Dietrich proud. She began working in the films of other directors, too: Ching Siu-Tung's *A Terracotta Warrior,* Sylvia Chang's *Mary From Beijing.* Eventually her relation-ship with Zhang Yimou fell apart. She became involved with a Singapore businessman named Ooi Hoe Seong and the two were married in a secretive civil ceremony in Singapore on February 15, 1996. A tabloid newspaper got ahold of the marriage certificate and printed it. Until then Gong Li had denied to the press she was wed, hoping, the actress said, to spare Zhang's feelings.

Wonderful films continued to slip out of China, some in the middle of the night, despite the constant vigilance and threats of the government. A few favorites:

SWORDSMAN IN DOUBLE-FLAG TOWN. A lone rider coming to get his woman finds the desert town under the brutal thumb of two warlords. A bit of Sergio Leone, a touch of Kurosawa, and memories of *Shane* and Randolph Scott, all filtered through director He Ping's idiosyncratic perspective and played out in an amazing desert dreamscape.

RED FIRECRACKER, GREEN FIRECRACKER. A wonderfully nuanced love story about the female manager of a fireworks factory and a wandering artist. Against all odds, in an environment of life-sapping traditionalism, passion is unleashed, poetically underscored by images of the rushing, violent Yangtze River. Another great film from He Ping.

THE HORSE THIEF. A breathlessly exciting and spectacular look at life in Tibet, an ever-touchy subject for Beijing. The story of an errant tribesman and family head, the horse thief of the title, forced into a peripatetic exile. Shot by Gen 5'er Tian Zhuangzhuang, who captures the wildness of 1920s Tibet with images of raw power.

LIFE ON A STRING. Chen Kaige's moving picaresque tale of a blind man's poetic quest for enlightenment, playing music on his *sanxian* until a thousand strings have broken, at which time he believes his sight will return. With a blind young disciple in tow he journeys through the wastes of Mongolia and, one way or another, into the light. Almost unbearable in its compassion and beauty.

THE WOODEN MAN'S BRIDE. In contrast to the slow pace and grimness of many Chinese period pieces, Huang Jianxin's film is a gutsy, rather cool revenge drama with slices of black humor. Bandit raids, kidnappings, mother-in-law jokes, all are in the story of a spunky young woman married off to a carved statue of her (unexpectedly deceased) fiancé, and the faith-ful servant-turned-leader of the Whirlwind Gang who saves her. As spirited and entertaining as the best crowd-pleasers from Hollywood and Hong Kong.

BLUSH. The ramifications of Revolution, from a female perspective, and a female director (Li Shaohong). Mao's men close the Red Happiness Inn, beloved whorehouse, and send the prostitutes for "reeducation." One, Qiuyi, escapes, and begins an amazing odyssey. Beautifully photographed, modestly sensuous, with a sweeping old-fashioned narrative sense that is in its own way reminiscent of the epic melodramas of Pearl S. Buck.

And more: *Farewell My Concubine, The Blue Kite, Temptress Moon, Letting Go, Stand Up, Don't Grovel!, Women from the Lake of Scented Souls,* in many cases films that challenged and charted the disintegrating moral authority of the Red government. Of course, the whole business with the censors was a bit of a game, as the authoritarian regime could stop productions entirely if it really wanted to, but there is money to be made from the films' international success and the investments of foreign coproducers (from Hong Kong, Taiwan, even Europe). Even as China took control of Hong Kong and fears ran rampant of an end to the former colony's free-wheeling movie industry, filmmaking within the People's Republic was becoming increasingly openly rebellious and uninhibited.

Breaking free of the Fifth Generation stereotypes—the lush, painterly images, period settings and peasants—newer filmmakers wanted to make films revealing of present-day China, warts and all. The acclaimed leader of the pack was Zhang Yuan, who graduated from Beijing Film Academy in 1989 ("Sixth Generation"). The director of *Beijing Bastards, Mama,* and *Sons,* his films, produced independently of the closely controlled studios, dealt with the realities of modern life, including such matters as sex, booze, mental illness, and domestic violence. An innovative experiment, *Sons* was a docudrama of an abusive, mentally unstable patriarch and his family, using the actual family to enact scenes from their depressing lives. Zhang Yuan's 1996 production, *Behind the Forbidden City,* had as its taboo topic homosexuality in the Chinese capital. The film's hero, a young writer, is arrested while cruising a park frequented by Beijing's gays and lesbians. In custody, grilled about his wayward ways, he reflects on love and his topsy-turvy life to a tough but—as the night wears on—increasingly sympathetic police officer.

Further evidence of the move away from the *objet d'art* cinema of before was *Keep Cool,* the 1997 production from Zhang Yimou. He was, after all, the primary creator of the slow, luxurious films of the first wave, but now the director went fully contempo in a comedy of amour and unlikely friendships in the Beijing of high-rise apartment blocks and portable computers. Significantly, Zhang abdicated his painter's eye for edgy images courtesy of cinematographer of the mode and Wong Kar Wai fave, Christopher Doyle. Meanwhile, China's antediluvian Film Bureau was busily refusing permission for other film projects and banning an assortment of finished films hoping for release, for reasons that were often quite opaque. Change was inevitable, change was here, but the government was determined to be the last to know.

Poster for the Chinese epic drama, *Blush.*

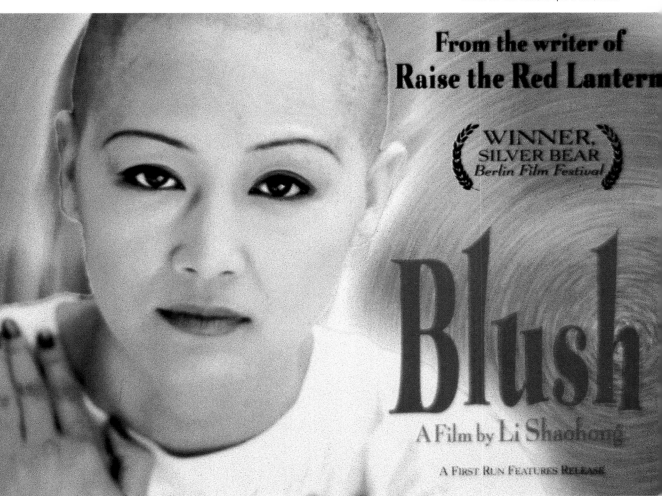

From the writer of
Raise the Red Lantern

WINNER,
SILVER BEAR
Berlin Film Festival

Blush

A Film by Li Shaohong

A FIRST RUN FEATURES RELEASE

T A I W A N

THE RELATIVELY BRIEF history of the Taiwanese cinema, begun after 1949 with the arrival of refugee film workers from the mainland, has been a choppy one, with many false starts and about-faces. The first films, coming early in the Kuomintang's rule of the island, were largely works of propaganda, uplifting the local government and attacking the scourge of Communism. Gradually, as private production companies and Hong Kong interests began to establish a beachhead in Taiwan, the government's hold on the film industry loosened, at least overtly. Indeed, for two decades the films of the Republic of China cautiously avoided all political or socially conscious content. A veteran of the Shaw Bros. operation in Hong Kong, Lee Han Hsiang arrived in 1963, establishing the Grand Movie Company. He and another Shaw graduate, Hu Chin-Chuan, would become the key producers of the slick and popular entertainments, costumed musicals, and sword-play films in the Hong Kong style that filled Taiwanese theaters for many years. In the midst of the martial arts boom in the 1970s, production in Taiwan reached an all-time high, with 200 fighting films made per year.

The tapering off of the kung fu genre, a general slump in the local box office, and the death of Chiang Kai Shek were factors that led to the so-called Taiwan New Wave of the 1980s. The government's CMPC (Central Motion Picture Corporation) began supplying funds for works it hoped would improve on the Republic's foreign image as a super-successful manufac-turer of sneakers. The directors who raised Taiwan's profile in world cinema circles—Hou Hsiao-

From Ang Lee's tale of food and family dynamics in Taiwan, *Eat, Drink, Man, Woman.*

Hsien, Edward Yang, Wan Jen, Chen Kun-Hou—dealt in the personal, the poetic, provocative social issues, and even political and modern historical controversies. Hou told what was largely his own story, a sensitive soul dealing with family tragedies and coming of age in the new republic, in the acclaimed *A Time to Live and a Time to Die* (1985). *In City of Sadness* he took on explosive subject matter, the Kuomintang's genocidal attacks on the indigenous Taiwanese. The American-educated Yang's early films, *Taipei Story* and *The Terrorizers,* held a mirror to modern Taiwanese society, affluent and alienated. The New Wave films, embraced by international festivals, met with a mixed reaction at home. Before, the local movies had been crassly commercial, but they were fun; many of the New Wave films were regarded as effete and opaque. As Taiwanese film critic Lan Tsu-Wei told historian John Lent at the time, "People here view movies as entertainment, not as a lesson. . . . the young directors think their mission is to impart their philosophies to audiences, and the audiences do not like this."

In the '90s came the "second wave," led by younger directors like Ang Lee and Tsai Ming-Liang, no less artful than the first. Ang Lee at least was thought to be more accessible and relevant to the ticket-buying public. His films *The Wedding Banquet* and *Eat, Drink, Man, Woman* tell stories of familial complications imbued with an unsentimental compassion and a subtle, but pervasive, vein of humor. In clear contrast to the *chinoiserie* of the mainland's exotic exports, Ang Lee's yuppie comedy-dramas could have been made in Europe or America only slightly rewritten. *Eat, Drink, Man, Woman* showcased a modern Taipei as prosperous, spotless, and bland-looking as Sweden. This "universality," plus Ang's sparkling bright visuals and inspired way with an ensemble cast, soon garnered him directing assignments for expensive Anglo-American productions, *Sense and Sensibility* and *The Ice Storm* for starters.

Tsai Ming-Liang's first feature (after some notable work in television) was *Rebels of the Neon God,* a stylish account of existential youth with an almost hidden-camera immediacy in its portrait of modern Taipei as an overlit, noisy video game parlor. *Vive L'Amour* dealt with similarly messed-up characters a little farther along in life, searching for emotional connections in a semidetached world where most human contact seems to be on the telephone.

Enjoying the attention of the world press and festival ribbons, and noting the woeful drop in local production, the Taiwan government has continued to subsidize its internationally known filmmakers. But recent works like those by first wavers Edward Yang (*A Confucian Confusion, Mahjong*) and Hou Hsiao-Hsien (*Goodbye South Goodbye*) were met with indifference by the public, if the films were released at all, and fared no better with the critics, who labeled them "auteurism run amok" for their alleged obscurantism and self-indulgence (Hou's first cut of *Goodbye* clocked in at six hours).

On the other hand, doing quite nicely at the box office and with nary a shred of international press attention was Taiwan's most successful and "least respected" auteur, Chu Yen Ping, "King of the Pop Flick." Prolific he is: for two decades Chu has averaged a new film every ten weeks or so. A conscientiously commercial moviemaker, following the latest trends as well as creating a few, his movies are works of pure entertainment. Typical Chu Yen Ping productions are the action comedies *Super Mischievous* and *Shaolin Popeye,* movies with the latest local pop stars and child actors playing adventurous monks. The great success of these and other titles have made

his the only local films to give Hollywood productions and Hong Kong's biggest names—Jackie Chan, Jet Li—a run for their money.

Starting as a low-rung assistant on kung fu movies, Chu found himself elevated to the director's chair while he was still attending college in his spare time. The first film, *The Clown,* paired him with a Chaplinesque comic actor named Hsu Pu-Liao. The film was a huge success and the team of Chu and Hsu went on to become a box office phenomenon, making more than thirty films together. Hsu, alas, became inextricably entangled with local gang lords, who took control of his later productions. The profits disappeared and Chu, kept working 365 days a year, was paid in Rolex watches by his unconventional employers. Hsu Pu-Liao's untimely death in 1985 shocked the nation. Chu had his ups and downs before a service comedy, *Bighead Brigade,* reestablished him as a commercial winner. From then on the hits kept coming. Many of them, like *Kung Fu Kids,* featured the antics of child actors. "Basically," he told *Sinorama* magazine, "I don't put any intellectual contemplation in my films and I don't try to express anything. . . . You don't see any college students watching my movies." Nine out of ten directors, he declared, "make incomprehensible movies that bore you to death!"

Chu Yen Ping's competition, of course, is not the art cinema of Hou Hsiao-Hsien, but the blockbusters from America and the superstars from Hong Kong. Seeking every advantage he can get against these mighty competitors, Chu is said to start each new film by leading cast and crew in a prayer to Tiangong, God of the Heavens, concluding with the spirited request, "Knock out Jet Li! And beat up Jackie Chan!"

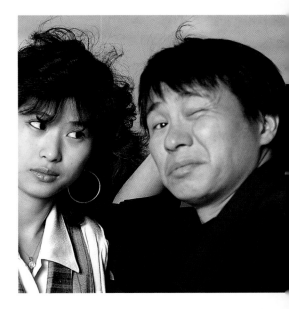

Director Hou Hsiao-Hsien with actress Hsin Shu-Fen. Photo by Robin Holland.

J A P A N

THE FIRST JAPANESE movies were made by Tsunekichi Shibata of Mitsukoshi Department Store's Photo Department in 1897. While other countries unveiled their flickers in a sideshow atmosphere, early Japanese screenings were often held within the formal confines of a kabuki theater, and took on the conventions of a traditional kabuki performance, complete with the banging of drums and an omnipresent *benshi,* or narrator. A major earthquake in 1923, destroying many of the film studio stages, encouraged a wave of more naturalistic filmmaking. Kabuki-style female impersonators were replaced by actual females, audiences making movie stars of pretty flappers like Sumiko Kurishima and Kinuyo Tanaka. The remarkable Kenji Mizoguchi made his directorial debut in 1923, Yasujiro Ozu his in '27. They became among the leading figures of the *shomin-geki* movement that favored realistic filmmaking about ordinary people and events.

Still making his way in the industry, Ozu took fascinating forays into unexpected areas, as in the 1933 silent crime drama *Dragnet Girl* (*Hijosen no onna*), with Kinuyo Tanaka as a gangster's moll turning her back on the underworld. Mizoguchi reckoned 1936 as the turning point in his career, the year he "finally knew how to show life as I see it," the year of *Osaka Elegy* and *Sister of the Gion,* unsentimental tales dramatizing Mizoguchi's sympathy for the travails of Japanese women.

The Japanese films of the 1930s, many of them gentle comedies and urban melodramas, show little evidence of the country's rising tide of militarism and gathering war

Masaki Kobayashi's magnificent *Kwaidan,* based on four stories by Lafcadio Hearn, and one of the true classics of fantasy cinema. Courtesy of Janus Films.

clouds. Even the more logically militant samurai stories seemed reluctant to reflect the signs of the times, though this was not without consequence. Sadao Yamanaka's film of 1937, *Humanity and Paper Balloons,* concerning a defeated, fatalistic warrior, so infuriated parties in the government that Yamanaka was soon "recruited" into the military and sent off to Manchuria, where he died in battle.

Propaganda prevailed during the war years, with many films produced for the jingoistic support of the military effort, though it has been said that Japan's war films offered a relatively temperate evocation of the enemy. Such assessments remain uncertain as most of the films were destroyed either in bombings or deliberately burned during the American occupation. Akira Kurosawa made his directorial debut during the war with his subversive paean to individualism, *Sanshiro Sugata,* slipping past the censors as a "tribute to judo." After Japan's defeat, the edicts of the homegrown censors were replaced by those of the U.S. Army, which put a ban on depictions of feudalism, imperialism, and samurai warriors. They allowed Mizoguchi to get back to work with *Utamaru and His Five Women,* approving as welcome pro-feminist propaganda the story of the free-thinking artist who exalted the female of the species. By the time control was returned to the national government in 1951, Japan's golden era of towering cinema masterpieces was well underway. Beginning with Kurosawa's *Rashoman* and *Ikiru,* Mizoguchi's *Life of Oharu* and *Ugetsu,*

Osaka Elegy, an early masterwork from Kenji Mizoguchi. Courtesy of Janus Films.

and Teinosuke Kinugasa's *Gate of Hell,* with its stunning use of Eastmancolor in a twelfth century–set melodrama, Japanese films found exposure and acclaim all over the world. *Sansho the Bailiff, Seven Samurai, Tokyo Story, Floating Clouds, The Burmese Harp, Throne of Blood*—the instant classics continued throughout the decade.

Commercial filmmaking after the war was the province of five major studios—Toho, Daiei, Toei, Shochiku, and Nikkatsu—each turning out scores of films every year through-

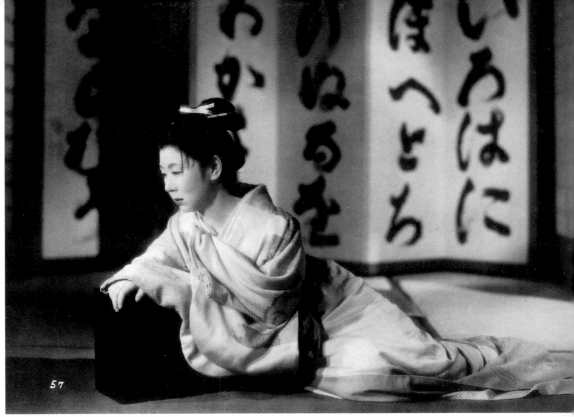

Mizoguchi's *Life of Oharu*, his elegant and moving tale of a seventeenth century concubine.

out the '50s and '60s. Most of the purely commercial productions, the cranked-out action pictures, comedies, and musicals (such as the enticing-sounding *Three Dolls* series—*Three Dolls in Ginza, Three Dolls Go to Hong Kong,* etc.) were never exhibited beyond Japan's shores. This was particularly unfortunate regarding the amazing array of expressive action movies of the '60s and '70s, seen by few non-Japanese until decades later.

In 1954 Japan introduced the great *Gojira* or, in the U.S. version, *Godzilla,* the first and best of the rubber-suit monsters to stomp a toy-sized Tokyo. Inspired by the success of Hollywood's *Beast from 20,000 Fathoms,* Toho producer Tomoyuki Tanaka suggested a similar story be set in modern Japan, developing the project with special-effects wiz Eiji Tsuburaya. The director assigned, Ichiro Honda, had experienced the fire-bombing of Tokyo and driven through the still-warm ruins of Hiroshima. He made the radiation-spitting Godzilla's rampage a terrifying metaphoric re-creation of the atomic blast and war's destruction. Honda became the Master of "Kaiju-eiga" (monster movies), directing the debut performance of nearly all of Japan's growing company of really big stars. The serious tone and harsh newsreel-like black-and-white photography of *Godzilla* gave way to the giddy fun and comic book colors of pop fantasies like *Mothra* and *Destroy All Monsters.*

The late '50s saw the first releases of the "new wave," the films of young directors such as Nagisa Oshima, Shohei Imamura, Masuhiro Shinoda, and others, who reflected in

story and style the increasing turbulence, radicalization, and disaffection in Japanese society, particularly the youth culture. The studios endorsed some of the first new wave efforts, commercially exploitable *taiyozoko* ("sun tribe"); that is, juvenile delinquent movies such as Shinoda's rock 'n' rolling *One Way Ticket for Love* or Oshima's *Cruel Stories of Youth,* an Asian cousin to Nick Ray's *Rebel without a Cause,* with flagrantly aesthetic use of widescreen and color. Yasuzo Masumura, whose *Kisses* (abrasive attitude and free-wheeling hand-held visuals) was a major influence on Oshima for one, made the wild satire of advertising, *Giants and Toys,* all widescreen anarchy and madcap directorial touches (like having his cast talk so fast they verge on white noise gibberish), and gave Daiei Studios a big hit. But subsequent, still more radical films proved too much for the commercial studios—Oshima's *Night and Fog in Japan* was virtually shelved by Shochiku, while Yoshishige Yoshida's nihilistic gangster picture, *Escape from Japan* (*Nihon dasshutsu*), had its final scenes of the hero going nuts behind bars scissored—which led the more ambitious iconoclasts of the New Wave to seek independence from studio control.

A most amazing chapter in Japanese filmmaking began in 1964 with director Takechi Tetsuji's *Daydream* (*Hakujisumu*), though "wet dream" would be more accurate, as it is an arty bit of erotic surrealism about an artist hallucinating about rape and torture while under a doctor's anesthetic. It was the first publicly screened film roughly falling under the definition of pornography and caused no end of uproar. The following year Tetsuji made the altogether more impressive and even more controversial *Black Snow,* a film that mingled sexuality, violence, and politics in its story of a screwed-up son of a hooker, impotent unless clutching a loaded gun, whose anti-Americanism and psychotic compulsions cause him to assassinate a black U.S. soldier, for which he is destroyed like a mad dog. Tetsuji was promptly arrested on obscenity charges. "I admit there are many nude scenes in the film," the director stated. "But they are psychological nude scenes symbolizing the defenselessness of the Japanese people in the face of the American invasion." Tetsuji was acquitted, paving the way for a wave of even more daring and nihilistic erotica, the era of the so-called "pink films." Though they were disdained as unclean in conventional circles, the pink films contained the most provocative and experimental moviemaking Japan had ever seen.

The leading figure in the pink film movement was Koji Wakamatsu, who had been a busy director of genre movies for Nikkatsu Studios in the early '60s, then in a huff went underground for the rest of the decade, making a series of disturbing "erotic" features. In *The Embryo Hunts in Secret* (*Taiji ga mitsuryo suro toki*) he explored the psychological demons and childhood memories in the mind of a young sadist in the act of torturing a woman, the accompanying music of a harpsichord completing the woozy, nauseating atmosphere. His *Go, Go, Second Time Virgin* (*Yuke yuke, nidome no shojo*) was a love story of the damned, depicting a young gang-

Throne of Blood, Kurosawa's brilliant version of *Macbeth*, starring Toshiro Mifune. Courtesy of Janus Films.

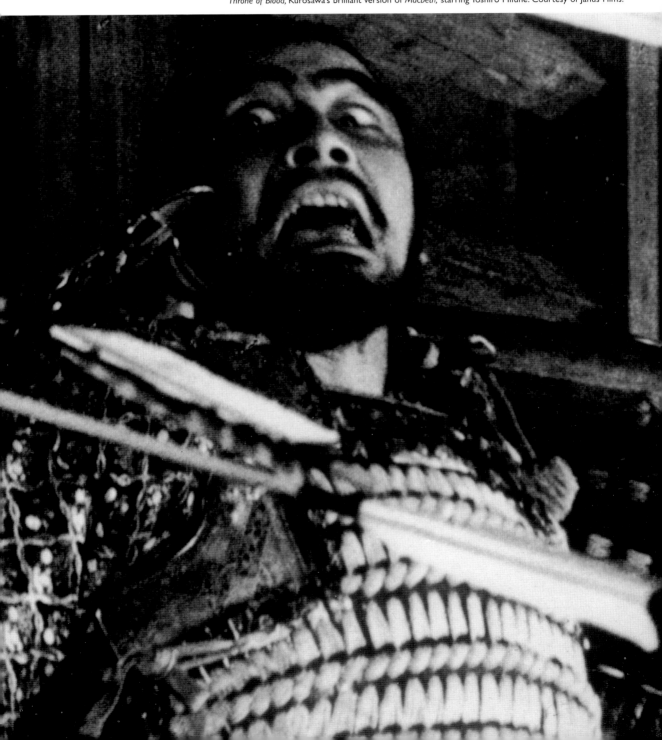

rape victim and a multiple murderer wretchedly clinging to each other before their predictably early demise. Wakamatsu reveals the girl's violent sexual history and the boy's horrifying backstory—his slaughter of a roomful of orgying swingers, including his parents—through fractured flashbacks and cutaways, switching from black-and-white to bloody, lurid color. *Violated Women in White* (*Okasareta byakui*), a spare, relentlessly cruel story of a psychopath's sexual rage, was inspired by the then-recent news report of a roomful of nurses murdered by American Richard Speck. The director used such elements as flash-cuts of tabloid crime photos and images of pop culture violence to convey larger sociopolitical implications, but Wakamatsu's greatest talent was in the visualization on film of pure unbearable nightmare.

The most popular Japanese genre of the 1960s and early '70s was the *yakuza-eiga*, the gangster film. There were gangland films made throughout the '50s, but *Abashiri Prison* in 1964 sparked the real craze for contemporary *yakuza* stories. The film starred Ken Takakura, who would become the undisputed king of the genre. Takakura, a taciturn Gary Cooper-esque actor, created the iconic *yakuza* hero, the good bad guy, dutiful, honorable, a modern samurai of sorts. Other popular *yakuza* stars and series were Koji Tsuruta in the *Gambler* series, and Junko Fuji, the "Lady Gambler," star of the *Red Peony* films. Though there were iconoclastic gangster pictures like the bizarre efforts of Seijun Suzuki, most of the countless '60s *yakuzas* (Toei alone produced over 300) followed a traditional formula, with a series of basic ritualized situations—the revealing of the tattoo, the self-amputation of a finger for some act of dishonor, the climactic bloodbath, etc.

Just as the audience began to tire of the traditional format, director Kinji Fukasaku revitalized it with his sensational *Battles without Honor and Humanity* (*Jinginaki tatakai*), a brutal, iconoclastic action epic of mobster violence in postwar Hiroshima. The film, and seven sequels, starred Bunta Sugawara, one of the cinema's all-time great tough guys. A different sort of hero from Takakura's noble urban warrior, Sugawara's Masazo was a ferocious, cynical, hot-

tempered hipster antihero. The films were a riot of brutal spectacle, directed with anarchic gusto. As if to show that the chaos and nihilism in the *Battle* series was just kid's stuff, Fukasaku then made *Graveyard of Honor and Humanity* (*Jingi no hakaba*), a delirious and grim *yakuza* flick about a self-destructing junkie hoodlum, filmed with a lurching, floating camera that vividly evoked the character's deranged perspective. In *Graveyard*'s most unforgettable moment, Tetsuya Watari chows down on the cremated remains of his ex-girlfriend. Other great *yakuza-eigas* from the nihilistic phase included Hideo Gosha's *The Wolves,* a stylish, bloody epic, and the same director's wild *Boyokugai* (*Violent Street*).

 Japan's film industry fell on hard times in the '70s, beset by shrinking box office, Hollywood, and television. Studios went bankrupt or scaled back production. In the case of the venerable Nikkatsu, all resources were shifted to the making of low-budget sex films known as "roman pornos," many with a sadomasochistic emphasis. Animated features began to make up an increasingly large portion of the annual output. Akira Kurosawa, Japan's most honored film-maker, was notoriously unable to get his projects funded. There were rumors of a suicide attempt. He made *Dersu Uzala* for Mosfilm in the Soviet Union. *Kagemusha* was financed by foreign investors. The final sequence in the latter film, released in 1980, was thought to be fraught with symbolic meaning: the traditional samurai swordsmen destroyed by the mechanical weaponry of the modern world.

Ken Ogata and victim in *Vengeance Is Mine,* Shohei Imamura's icy account of an enigmatic serial killer.

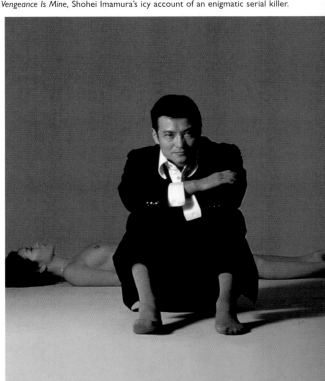

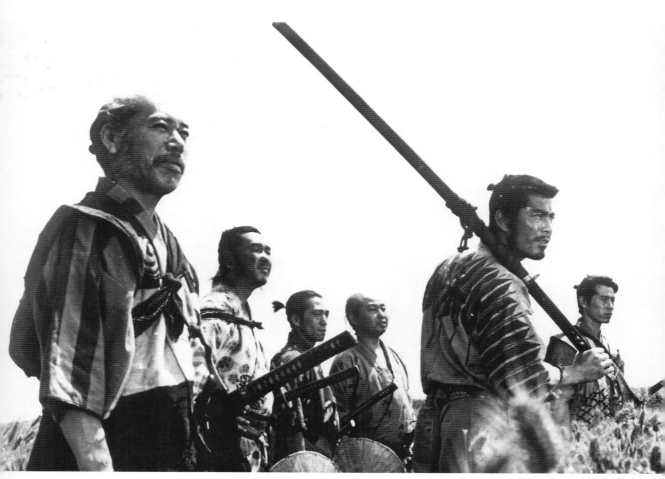

A scene from *Seven Samurai* by Akira Kurosawa. Courtesy of Janus Films.

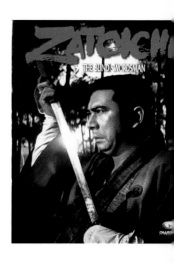

S W O **R** D

T H E A T E R

CHAMBARA, THE JAPANESE historical action genre, reached an early maturity with Akira Kurosawa's 1954 production of *Seven Samurai*. Swords had been drawn before this, and *jidai-geki,* period costume films, had been a staple of Japan's cinema from the beginning, but Kurosawa's powerful, exhilarating tale of men in battle was the obvious point of departure for the hundreds of violence and adventure-filled *chambara* films to follow (the term itself is drawn from the sound of clashing steel). *Seven Samurai* has been referred to as the first "Eastern Western," and, of course, its premise of warriors defending a village from bandits translated quite effortlessly into horse opera in *The Magnificent Seven*. It is a superficial reference, since no other western or "action" film of any kind has ever matched the poetry and profundity of Kurosawa's three-and-a-half-hour masterpiece (including *The Wild Bunch,* the greatest of the films clearly inspired by its lyricism and orgiastic climax). Stylistically revolutionary, light years away from the stately, formal pictorialism of classical Japanese cinema, *Seven Samurai*'s raw muscular images, the use of telephoto lenses, multiple cameras, and quick-cut editing, gave scenes the jagged edges and unsettling tension of combat photography. The film took more than a year to shoot, six weeks in mid-winter just for the climactic battle in the rain and mud (and worth every second of it to create this staggering set-piece, the greatest action sequence of all time).

Above: Zatoichi, the blind swordsman.

Seven Samurai expressed an ambivalent romanticism toward feudalism's warrior caste, showing it to have spawned both the decent and self-sacrificing septet (honorary status for Toshiro Mifune's enthusiastic farmer's son) and the heartless brigands, and in the end Kurosawa gives victory only to the simple villagers. By the time of *Yojimbo* (1961), ambivalence has curdled into cynicism in a film about a slovenly freelance swordsman who cleverly fights for both sides of the conflict at once (this too translating into a Wild West remake, unofficial this time: Sergio Leone's *A Fistful of Dollars*). *Sanjuro,* a sequel made the following year, went a step further into outright satire, with its scoundrelly hero and clueless samurai. Kurosawa, ever a pioneer in the staging of visceral action, gave the film's climax a joltingly memorable special effect as Sanjuro slices his opponent and a geyser of blood sprays into the air, upping the ante on movie violence with a single sword stroke.

Kurosawa's comic dismantling of the samurai mystique opened the way for a new era of antiheroics, expressive wallows in caustic anarchy and brutal nihilism. Kihachi Okamoto's *Sword of Doom* features an outright psychotic as its skilled swordsman protagonist. A figure of emotionless evil as brilliantly portrayed by Tatsuya Nakadai; the swordsman Tsukue's first action is the meaningless slaughter of an old grandfather who has the misfortune to cross his path. Raizo Ichikawa, the "Japanese James Dean," made a trademark out of his alienated samurai roles, first in *Destiny's Son* (directed in hallucinatory style by Kenji Misumi), and then as the iconoclastic Kyoshiro Nemuri in nine of the films in the *Son of the Black Mass* series (Hiroki Matsukata played the role in the final two titles after Raizo Ichikawa's untimely death from cancer in 1969). Kyoshiro Nemuri, outcast half-breed sword-for-hire, is an angry young man haunted (literally, in lurid dream sequences) by his ugly heritage, his mother's rape by his devilish Portuguese missionary father, and her subsequent suicide. He goes through life brooding and slicing up opponents, only rarely permitting a shred of humanity to surface. The character's deadly distinction as a swordsman is the mythic "full moon cut," a circular swing of his blade that has a mysteriously hypnotizing effect on the opponent. A dark and bizarre series it was, full of decadent psychos, royal perverts, beautiful sadists, and heated Christian-bashing.

An altogether more likable, though no less lethal, series character was Zatoichi, "the blind swordsman," whose adventures were chronicled in twenty-five feature films between 1962 and 1973 (among the best: *Zatoichi and a Chest of Gold, The Blind Swordsman's Fire Festival, Zatoichi and the Chess Expert,* and *Zatoichi Meets Yojimbo*). The films were hugely popular in Japan and made of the blind man's screen incarnation, Shintaro Katsu, a beloved superstar. Shintaro, a boxy large-headed man, played his masseur-gambler-killer as a lovable imp with a Chaplinesque bowlegged waddle, a plug-ugly sad sack known to walk into pissing horses and be chased by pesky dogs, making it all the more startling when his sword goes into action and the bodies begin to fall. The series' great popularity led to a gender-switched rival, *The Crimson Bat,* delightful, action-packed adventures of sightless, sword-swinging Oichi, played by Yoko Matsuyama in the four-film series (*Crimson Bat, The Blind Swordswoman; Trapped, The Crimson Bat; Watch Out, Crimson Bat;* and *Crimson Bat: Wanted, Dead or Alive*). The Crimson Bat was only one of many female swordfighters in '60s–'70s *chambara,* whose ranks included Quick Draw Okatsu, played by Junko Miyazono, and Michiyo Yasuda's *One-Eyed/One-Armed Swordswoman.*

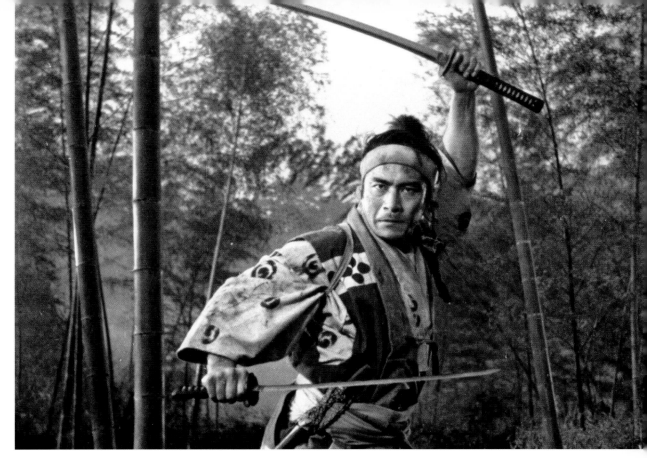

Toshiro Mifune as Japan's controversial hero of seventeenth century Japan, Musashi Miyamoto. Of the many versions of the warrior's story, the most distinguished is the Mifune-starred "Samurai Trilogy" by director Hiroshi Inagaki. The films, *Musashi Miyamoto, Duel at Ichjoji Temple,* and *Duel at Ganryu* were produced between 1955 and 1957 in exquisite color. Courtesy of Janus Films.

Shintaro Katsu took Zatoichi to success on television in the '70s, then returned to the big screen for a final glorious send-off in 1989. The actor played one other remarkable character, the impossible-to-ignore Hanzo, the Razor Sword of Justice, Edo Period Japan's greatest constable, in three features made at the tail-end of the Zatoichi series in 1972–74 (*Fangs of the Detective, The Razor's Torture Hell,* and *Hanzo, the Devil, the Flesh and the Gold*). The three films tend to leave the unprepared viewer's mouth gaping in disbelief. In the course of his criminal investigations, Hanzo uses decidedly unorthodox methods of interrogating females, most notably through the "torture of pleasure," screwing the suspects into confessing all. Hanzo is indicated to possess a penis the size of the Kamakura Buddha and keeps it interrogation-ready by pounding it against a stone anvil, among other odd exercises. Considering the political fuss engendered in America by Dirty Harry's relatively gentle tactics in this same period, it is not surprising that Hanzo's raping, torturing police investigator did not get much exposure on U.S. shores.

Spaghetti westerns such as *For a Few Dollars More, Django Kill!,* and Peckinpah's *The Wild Bunch* were clearly influenced by the nihilism and stylized action scenes in earlier samurai films. In turn, the spaghettis and Peckinpah obviously had their impact on '60s–'70s *chambaras,* with their increasing emphasis on pure style and nonstop bloodshed, cool heroes in the Eastwood tradition,

swordfights scored to the anachronistic surf twang of electric guitars. The crosshatching of influence could be seen in films like Okamoto's *Kill!* with its pair of *ronin* (masterless samurai) slobs and a jangling Morricone-esque soundtrack, or Eiichi Kudo's *The Fort of Death,* blazing Gatling gun evoking *The Wild Bunch's* noisy climax, the reverse pattern continuing in efforts like *Red Sun,* a Euro-western featuring Toshiro Mifune, and in the Tony Anthony revision of Zatoichi called *Blindman.*

The most expressive Japanization of the Leone/spaghetti westerns might be the six-film series known as *Lone Wolf and Cub,* based on the *manga* (comic book) by Kazuo Koike. Many of the early *chambara* classics were intellectually rigorous, historically detailed works such as Kobayashi's *Samurai Rebellion* and *Harakiri,* films that took serious stock of society and politics during Japan's feudal era. By contrast the Lone Wolf films were stripped to essentials, red-hot visuals propelled by ever-inventive bouts of elaborate and explicit violence. The series followed the sanguinary adventures of Itto Ogami, the Shogun's decapitator, betrayed by rivals, his wife murdered, now forced to hit "the road to hell" with his young boy Daigoro in tow (the series is also known as *The Baby Cart,* after the perambulator in which cute little top-knotted Daigoro resides, a wooden box stuffed with more hidden weaponry than James Bond's Astin Martin). The series was produced by Zatoichi himself, Shintaro Katsu, as a vehicle for his younger brother, the similarly stocky Tomisaburo Wakayama, a far cry from the strapping hero of the *manga,* but whose grim-faced visage and stoic aura beautifully evoked Itto Ogami's tragic worldview. Four of the six films were directed by the very talented workhorse Kenji Misumi (his nonstop high-energy filmmaking in the '60s and early '70s perhaps contributing to his death at the age of 56), who filled the ultra-widescreen canvas with a kinetic flow of inventive stagings and spraying rivers of blood.

Although they have become cult items in the West, the *Lone Wolf and Cub* films were not particularly popular on their release in Japan in '72 and '73. It was an indication of the waning interest in the *chambara* (the western, too, was ending its run as a viable genre at about the same time). Both the Lone Wolf and Zatoichi transferred to television, with tamer action and none of that dazzling widescreen imagery. Some directors remained committed to the *chambara,* most notably the brilliant Hideo Gosha. Perhaps the greatest of all genre directors to specialize in samurai cinema (Kurosawa, godlike, is above such rankings), a dazzling visual stylist and incisive dramatist, Gosha filmed his first feature, *Three Outlaw Samurai,* in 1964, and continued to make original, expressive, and explosive use of the genre for more than twenty years. His colorful classics include *Goyokin* (with its unforgettable swordfight in the snow), the splendidly anarchic *Bandits vs. Samurai Squad,* and the dark, stylized *Death Shadows* (*Jittemai*), a tale of mute samurai avengers and beautiful female criminals, shot entirely on dreamlike studio sets. Gosha's death in 1992 went virtually unreported in America, shocking neglect for one of the world's greatest—and most entertaining—filmmakers.

A modest revival of the samurai genre has been underway in Japan of late, though it seems as yet unable to recapture the dramatic power, visual spectacle, or frequent outrageousness of the decades-old originals. Suffice it to say: the 1992 big-screen return of *Lone Wolf and Cub* did away with Daigoro's baby cart.

Above: Three bandits attack a blind man, to their eternal regret, in *Zatoichi and the Chest of Gold*. Below: The attack in the snow: Toshiro Mifune defends himself against assassins in Kihachi Okamoto's grim, nihilistic *Sword of Doom*. Courtesy of Janus Films.

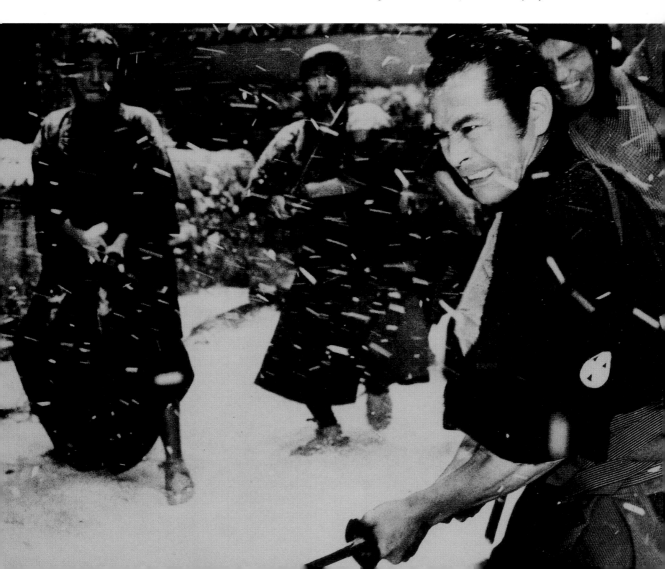

SEIJUN SU**Z**UKI

THE VERY BELATED discovery in America and Europe of the works of Seijun Suzuki, crazed surrealist visionary of the *yakuza-eiga,* made clear that all prior asssessments of the crime genre were akin to histories of the Western written without knowledge of, say, John Ford. In the 1960s director Suzuki took a series of studio assignments, formula-B movies with three-week shooting schedules, and transformed them into vehicles for wild-eyed visual adventurism and spectacular nihilistic cool. In such delirious pop art masterworks as *Gate of Flesh, Tokyo Drifter,* and *Branded to Kill,* the director deconstructed conventional narrative moviemaking with the use of bizarre camera angles, color coding, feverish lapses in logic and continuity, Brechtian distancing and anti-naturalistic theatricality (think Lewis's *Ladies Man* set aswarm with brutal criminals). Raising his maverick artist status to the level of the mythic, Suzuki's formal experimentation was done with the express disapproval of his employers and eventually led to his firing, followed by a riotous public protest, a victorious legal suit, and a decade-long blacklisting. Suzuki claimed he had only been trying to keep the damn audience from getting bored.

Born in Tokyo in 1923, Suzuki was drafted into the army during World War II. He saw combat, and had two ships sunk under him. The experience of having death all around, at times occurring under strangely comic circumstances, gave him an exalted sense of the absurd. After the war Suzuki joined Shochiku studios as an assistant director, then shifted over to Nikkatsu, where he wrote screenplays and directed his first film, a musical, in 1956. He was soon specializing in violent subject matter, films with titles like *The Nude and the Gun, Fighting Delinquents,* and *Detective Bureau 2-3: Go to Hell, Bastards!* Suzuki was considered one of the studio's contract hacks,

The hitman as weirdo: Seijun Suzuki's *Branded to Kill.*

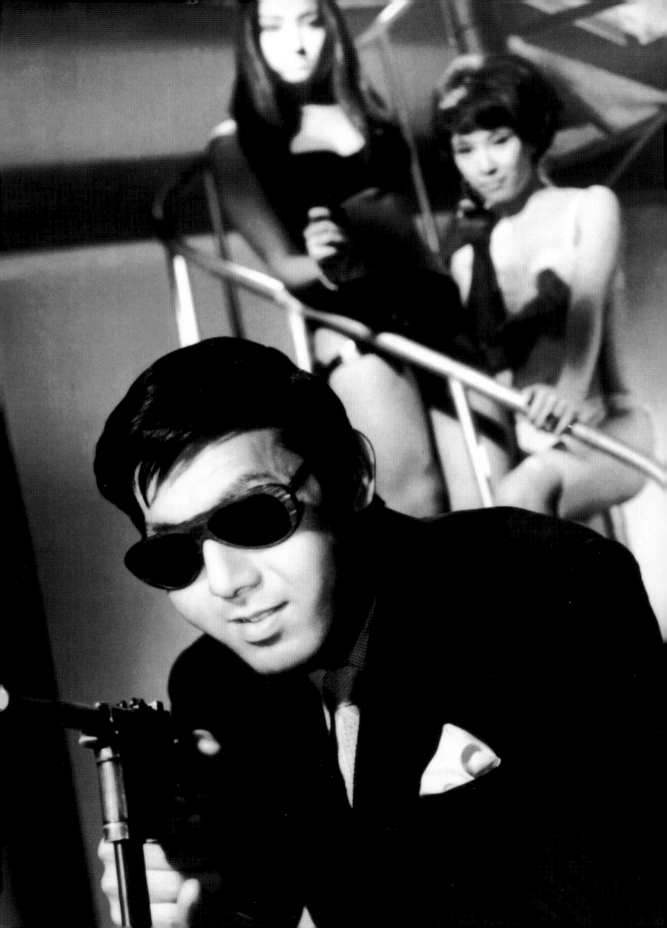

charged with helping to keep up Nikkatsu's schedule of eight new films per month, programmers budgeted at between $50,000 to $100,000. "It wasn't an issue of whether I liked a project or not," Suzuki recalled years later. "The company told you to make them and you can't say no."

Though many of his early works remain subjects for further research, Suzuki's subversive impulses appear to kick into high gear by 1963 with the gangland opus *Youth of the Beast* (*Yaju no Seishun*), with its shifts from black and white to color (and b&w with significant splotches of color), scenes shot through transparent glass floors, floating see-through drug dealers, and patently unreal stagings such as the horsewhipping of a hooker amid an incomprehensible golden yellow windstorm. Action scenes are laid out with a wild dynamism, as comically over-the-top as they are ingenious: a dozen or so micro Toyotas loaded with gangsters in a careening gun battle staged like a demolition derby, and later a quick-draw shootout with the hero suspended upside down from a chandelier. Suzuki crams his anamorphic compositions to the bursting point. A scene in back of a screening room dazzles the eye even as it undercuts the narrative: on the right, dialogue and a shotgun confrontation, in color, while the left side of the screen contains a speedboat chase in an anonymous black-and-white movie. Suzuki defies you not to give up his hackneyed storyline and watch the other guy's old footage.

Gate of Flesh, his "pink" film of young prostitutes, submission, and degradation in postwar Japan, and the prewar-set *yakuza* film *One Generation of Tattoos,* displayed increasing expressionism, the latter eliciting a warning from Suzuki's studio bosses that he had "gone too far." For the subsequent *Tokyo Drifter,* Suzuki claimed he had "complied with their wishes." This, of course, was a matter of opinion. The film, a hectic *yakuza* epic, mixed unhinged aestheticism and narrative chaos. The wide screen glows with '60s pop-cult as hallucination: big-finned American cars under a fish-eye lens, sharkskin, neon, lavender nightclubs, swaggering hoods in sky-blue suits and white bucks, a tough-guy hero who breaks into bluesy pop songs when the mood hits him. Think *Ocean's Eleven* viewed on spiked Kool-Aid.

The following year—'67—Suzuki made *Branded to Kill,* widescreen but in a (presumably) more restraining black and white. It is the story of Japan's number-three ranked hit man, an eccentric assassin who becomes sexually aroused by the aroma of freshly cooked rice. Number Three dispatches his victims in fiendishly clever ways. One man eats a bullet fired up through a bathroom sink from another floor. Or something. Watching Suzuki's films it is at times hard to believe what you've just seen. As entertaining as it is unreservedly weird, *Branded* was the studio's last straw. Accusing him of making "incomprehensible and unprofitable films," Nikkatsu abruptly dismissed him after nearly a dozen years with the company. A cult favorite among Japanese student intellectuals, Suzuki's firing caused them to launch a noisy protest. The director sued the studio, the case took four years to win, and afterward Suzuki found himself blackballed in the industry.

For ten years he made no features, surviving by writing and doing an occasional TV commercial. Not until 1977 did he direct another movie. In 1980, forming a partnership with independent producer Genjiro Arato, he filmed *Zigeunerweisen,* a strange, elegiac quasi-ghost story set in the Taisho Era of the 1920s. When distributors refused to show the picture, Suzuki and Arato took it around the country in a specially built mobile projection apparatus. The film was

eventually voted the greatest Japanese film of the decade. He followed it with *Heat-Haze Theater* and, in 1991, *Yumeji,* more saturated color dreams of love and death, completing the so-called Taisho Trilogy. Other projects have been announced but never begun. "Not doing anything is the best thing for me now," Suzuki told a reporter early in 1997, at the age of 73. Letting a growing world audience ponder his extraordinary films, Suzuki was resigned to returning home and "gazing at the white clouds," no doubt imagining how much better they might look in electric yellow or shocking pink.

Left to right: Scenes from Suzuki's delirious *yakuza* classic, *Tokyo Drifter;* Suzuki is the crime film's great surrealist. Here a powder blue–suited hoodlum takes his girl for a walk on the railroad tracks. This page, center: Violence solves everything: another meeting of minds in *Tokyo Drifter.* All photos courtesy of Janus Films.

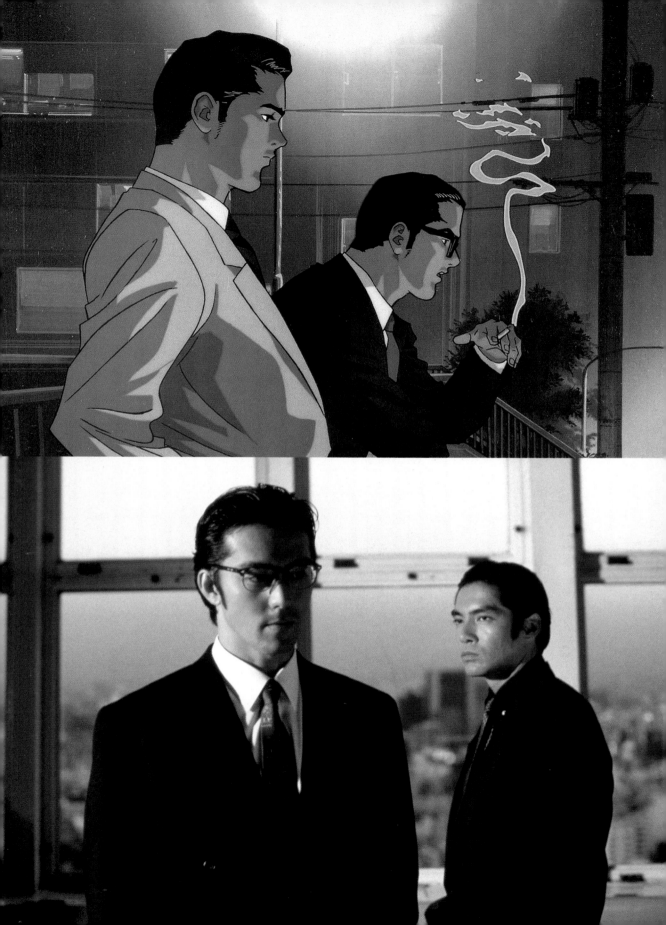

JAPANESE
CIN**E**MA
TODAY

THE DEATH RATTLE of Japanese cinema had been sounding for nearly thirty years. As the end of the century neared, audience attendance had fallen to one-tenth the figures of the 1960s, and there remained but one—mostly decrepit—screen for every 68,000 citizens. Animation (brilliant creations far outnumbered by the mundane) had become more popular than live action features and an ever-increasing majority of all film production was conceived directly for the slag-heap of electronic transmission, with all the diminished expectations that implied. Under the circumstances, it was a miracle how much interesting and original stuff was out there.

The climate of the times no longer inspires the humanist epics, the sublime art works, or the poetic character studies of the postwar decades, or for that matter the rancorous experimenting of the '60s new wavers. The obsessions of the previous generations of directors and screenwriters—history, national identity and character, revolutionary politics, feminism and other social causes—are of interest to relatively few new filmmakers or their audiences, with occasional exceptions such as assorted message-bearing *anime* features and the spate of modish films addressing gay rights, *Okoge* (*Fag Hag*), *Kira Kira Hikaru* (*Twinkle*), and others. The distinguished global hits and award winners of recent vintage—*A Taxing Woman, Shall We Dance?*, etc., sitcoms with a soupçon of lyricism—reflect a bourgeois sensibility borne of economic prosperity and television, while the most radical commercial filmmakers these days tend to find their inspiration in pop sources: trash and pulp culture, comic books, science fiction, heavy metal music, pornography. Much of modern Japanese cinema shows the influence of newer pop formats, video games, and *mangas* (top-selling comic-book literature, roughly translated as "irresponsible pictures"), spiritual and literal adaptations, cartoonish, post-literate, sensory-overloaded entertainment for the crowded society on the go.

Two versions of the flashy crime drama, *Sanctuary:* live action and animated, both in turn derived from a popular comic book. An increasing number of live action films in Japan are adapted from *manga* or *anime* sources. Courtesy of Viz Communications.

As Hollywood turns to lousy old TV shows for material, Japan's most frequent source of inspiration is the *manga*. In some cases the comic book-derived movies have already been filmed in an animated version, while others—such as the popular *Sukeban Deka* films about a special police unit of high school girls, experts in the lethal use of special razor-edged yo-yos—have come to features by way of television. Some live action movies—*La Blue Girl*, for example, and *Kekko Kamen*, the nude masked superheroine who disorients her foes by flashing them—are indeed like living comic strips. While much of the *manga* world is aimed at men, *shojo manga* are a female-oriented division, written for the most part by women. One of the most dramatic and controversial works in the history of the form was *Father Fucker* by Shungiku Uchida, the story of a 14-year-old girl who becomes mute from the traumatizing sexual abuse by her stepfather. The story was brought to the screen by the colorful Genjiro Arato, previously known as the producer who brought cult director Seijun Suzuki back into the spotlight with his Taisho Trilogy. Arato made his directorial debut with *The Girl of Silence,* a powerful adaptation of Uchida's shattering story.

As far as controversial *manga*-derived movies go, the *Rapeman* series represents, vis-à-vis Western mores, the Waterloo of nonexportable cultural standards. The films are startlingly light-hearted, medium-budgeted adult thrillers (meant for a general audience, not the porn crowd) about a pair of supposed do-gooders, a goofy old man and his earnest young teacher-nephew, who run the Rapeman Service, serving clients who have been wronged by cruel women (their motto: "Righting wrongs through penetration"). Dressed in the black leather and woolen mask of a burglar, Rapeman breaks into his victims' homes and sexually assaults them. The fees they receive from their vengeful clients are given to their favorite charity, a struggling orphanage.

In Japanese cinema's pure pop climate it was not surprising to see a revival of the monster and science fiction genres, once the bread and butter of the country's celluloid exports. *Godzilla, Mothra, Gamera,* and other rubber-suited or kite-like icons had fallen on hard times after their heyday in the 1960s. Only the Godzilla series continued through the '70s with any sort of regular production schedule, and these later efforts declined into childishness with a tender-hearted dinosaur defending the environment and doing other good works. With *Godzilla 1985,* at least, Toho put their franchise back on the path of evil destruction, though the movie didn't hold a candle to Honda's savage black-and-white original from thirty years earlier.

More recently, old favorites and also-rans Gamera (Daiei Studios' plump flying turtle of the '60s, and the Toho clan's only serious rival) and Ultraman (TV's fave alien superhero in the red gymnast suit and cool bug-eyed helmet) have been successfully revived for the big screen, writers and directors taking a hip approach that appeals to both simon-pure kids and fanboy cultists. *Gamera, Guardian of the Universe,* with special effects light-years beyond the old toy model cities and parade floats of the past, is a delight; well-scripted and vigorously directed, with the old flying turtle looking better than ever. *Ultraman Zearth,* more kid-oriented and smaller-scaled to be sure, also perfectly captures the energetic fun of the original material, or at least something analogous to the cherished memories of the originals.

Not all of the new monster/fantasies were in the classical or nostalgic realm. Trying to go up against Hollywood's high-tech alien horrors was *Zeiram,* directed by Keita Amemiya as a kind of 35mm video game. The first *Zeiram*'s simple premise was an excuse for

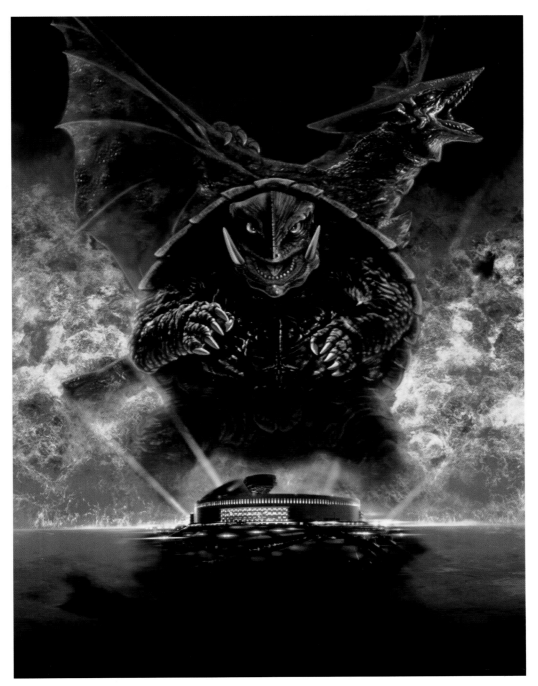

Gamera, Guardian of the Universe, directed by Hideaki Anno.

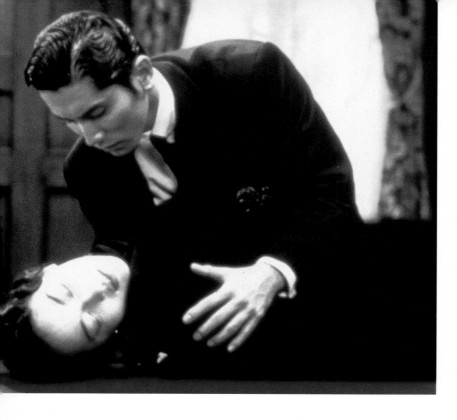

almost nonstop action; the sequel, *Zeiram 2,* was an even more down-to-basics viewer-passive version of a viddy game, with perpetual explosive action. The title character was a ferocious bio-mechanical creature from outer space, an out-of-control killing machine cloaked in samurai garb that disguises an *Alien*-like metal monstrosity with savory bits of revolting organic matter. Taking on the job of vanquishing the beast is a female bounty hunter, Iria, played with ice-cool charisma by Yuko Moriyama. Dressed in a clinging uniform, equal parts white spandex and black leather, Moriyama's fearless Iria makes previous sci-fi tough gals like Sigourney Weaver's Ripley look like members of a quilting bee. Moriyama is so stoic and just-the-facts deadpan as the bounty hunter, that a making-of featurette showing her laughing comes as quite a shock, like seeing a mannequin spring to life. *Moon of Tao,* a Tsui Hark-like fantasy adventure, also featured the alluring actress as a tough monster-slayer, this time with a new black leather costume and hair colored a fetching platinum blonde. Yes, you could say Yuko was a favorite of mine.

Of course, there is more to modern Japanese filmmaking than good-natured pop and pulp. The times may not abide or afford another Kurosawa or Mizoguchi, but there is no lack of interesting and quirky cinematic talent on hand. Shinya Tsukamoto, for example: a cyber-punk visionary whose films feel like the nightmarish spawn of a youth culture raised on a strict diet of brutal *manga* images, deafening electro-video parlors, and industrial waste. In *Tetsuo: The Iron Man,* a fellow with a fetish for metal opens his flesh and stuffs it with cable. A careless salary-

Left: From Kazuyoshi Okuyama's *The Mystery of Rampo,* a surreal investigation of the life and art of Japan's great pulp writer. Opposite: Yuko Moriyama attempting to vanquish the alien in *Zeiram;* a platinum blonde Moriyama in *Moon of Tao;* the beautiful Yuko Moriyama, star of *Zeiram* and *Moon of Tao.*

man finds himself growing alloy whiskers. The hero's penis turns into a frightening power drill. Filmed in 16mm knife-sharp black and white, Tsukamoto's first film was a short, intense ode to metal mutation. *Tetsuo II: Bodyhammer* was a variant remake in color, a postpunk *Straw Dogs* quaking with apocalyptic rage. For his third feature, *Tokyo Fist,* Tsukamoto conceived his first, at least superficially, normal narrative: a wimpy insurance salesman loses his fiancée to a treacherous old acquaintance, a professional boxer, and then begins a painful regimen to beat the rival at his own game. This time Tsukamoto pursues the theme of painful metamorphosis with strictly human ingredients, especially blood. The director, starring as the bitter salaryman as well, shoots with a patented supercharged technique, the cinematographic equivalent of the pounding blows that turn his boxer's face into raw meat. A kind of postmodern, adrenaline-overdosed Cronenberg, Tsukamoto creates a vivid portrait of a psychotic, contaminated world.

 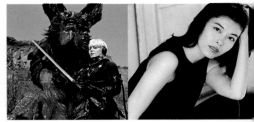

A first-time director (and second-generation Shochiku executive), Kazuyoshi Okuyama got his career off to a brilliant start with the phantasmagoric *Rampo* (*The Mystery of Rampo* in America). The work of Edogawa Rampo, Japan's great prewar pulp writer, has been the source of some of the country's most provocative motion pictures, including Masumura's bizarre S&M thriller *Moju* (*Blind Beast*) and Fukasaku's campfest *Black Lizard*. In Okuyama's stately hallucination of a film, the author himself is the protagonist of a story as mysterious and kinkily erotic as his own strange fiction. The film blends the writer's reality and imagination into a seamless dreamland where fictional characters can have quite an impact on the natural world. "Rampo," said Okuyama, "found more value in things he could feel or draw in his heart than objects that could be seen or surround him. He created an inner utopia." In *Rampo,* events from the writer's stories seem to be coming true, even as the government censors declare his work grotesque, obscene, and unreal. A modern classic of surrealist cinema.

Even more oneiric images are to be found in the works of Sogo Ishii, one of the most intriguing and accomplished of modern Japanese filmmakers. Ishii has created films that

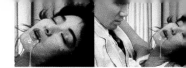

cover an amazing range in style and attitude, with, at this writing, at least three distinctive phases in his amazing filmography. Phase one: After making a splash with an anarchic, violent student film, he directed his first feature, the explosive *Crazy Thunder Road* (1980), a ruthlessly over-the-top biker-gang flick. *Blast,* in 1981, was a mock chase film that didn't bother with exposition or making sense, continuing *Crazy Thunder Road*'s convulsively hyped-up style. *Crazy Family* (1984) mocked a conventional hit, *Family Game,* with a fiendishly funny tribute to a clan of dysfunctional lunatics destroying their home in the pursuit of ants. Having gathered a cult following with these exercises in surreal anarchy, Ishii promptly dropped off the map (phase two), withdrawing from commercial features to labor in near obscurity on some short subjects and keeping a quirky filmed diary with an 8mm camera. It would be ten years before he surfaced with the wonderful thriller *Angel Dust.* Phase three: Instead of the old anarchic punk frenzy, Ishii now filmed in a mood-drenched, narcotic style. His story of a blank-faced clairvoyant policewoman investigating the murders of young women with a hypo needle on the Tokyo subway proceeds with a quiet, chilly creepiness. *August in the Water* continued in this moody realm with a strange and original story involving mysticism, astrology, and high-diving. A still more opiated atmosphere pervades *Labyrinth of Dreams,* a suspense tale of a fatalistic female bus conductor and her near-fatal attraction to a serial-killer driver. Ishii's haunting dream images slowly overwhelm, like floating in a pool of warm water that imperceptibly begins to boil.

Perhaps the most distinguished of recent Japanese filmmakers, at least in terms of awards and mainstream critical acceptance, particularly in the West, was Juzo Itami. Itami had been an actor in movies for more than twenty years before directing his first film in 1985, *The Funeral,* a black comedy. His breakthrough was his second feature, *Tampopo,* an antic spoof tribute to ramen and spaghetti (westerns). The free-wheeling blackout sketch style of the film showed the influence of TV variety shows. A vehicle for his wife, impish, freckled Nobuko Miyamoto, *A Taxing Woman* was Itami's first straight-ahead narrative, a conformist comedy/drama about a female tax collector out to bring down Tsutomu Yamazaki's corrupt magnate. Despite the unappealing nature of the premise and the leading lady's profession, the film was remarkably well-received both in Japan and abroad (Best Picture at the Japanese Oscars, Ten Best lists in America), and a successful sequel—*A Taxing Woman Returns*—followed. Much better was *Minbo,* subtitled in English *The Gentle Art of Japanese Extortion,* a satiric indictment of the *yakuza,* with Itami's favorite bureaucratic superwoman Miyamoto playing a lawyer who humiliates the thick-witted gangsters. *Yakuza* thugs were used to looking supercool on screen, not like horses' asses. One night not long after the film's successful opening, local gang members approached Itami and slashed him with a razor. He was hospitalized for several weeks. The more recent *Supermarket Woman* took on a less predictably problematic subject for ridicule—food retailers—Miyamoto playing yet another cute authoritarian. But with his tenth film, *Woman of the Police Protection Program,* Itami was back on dangerous ground. The story, inspired by the Aum Shinrikyo doomsday cult, was about a woman who witnesses a murder involving a wacko religious group, forcing her to go underground in the police witness protection program. It would be Itami's final production. On an evening in December 1997, the filmmaker jumped off the roof of his eight-story office building, killing himself.

Top left: From Itami's "ramen Western," *Tampopo.* Bottom left: *Minbo.* Above: From Juzo Itami's *A Taxing Woman Returns.*

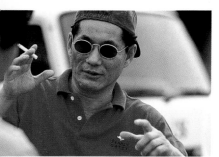
Kitano directing *Kids Return*.

TAK E SHI!

HERE!

JUDGED BY ANY conceivable standard, "Beat" Takeshi Kitano, Japan's legendary multimedia star, must be ranked as one of the more fascinating figures in the annals of modern popular culture. With a series of strange and brilliant films to his credit—most notably *Violent Cop, Sonatine, Kids Return, Hana-Bi*—off-kilter contemporary dramas, most with strong elements of cold-blooded violence and deadpan humor, Kitano has established himself as a major presence in world cinema. A growing favorite of critics and festival juries, international audiences have only the slyly power-ful films he has directed and usually starred in (plus the occasional scene-stealing performance in someone else's movie, including *Merry Christmas, Mr. Lawrence; Johnny Mnemonic; Gonin*) by which to admire his talent.

In his own country it is another matter entirely.

A slapstick comedian turned television personality turned overwhelming media omnipresence, Kitano has for many years been a dominating figure in Japanese television, radio, books, newspapers, magazines, and the gossip of a citizenry appalled and elated by his headline-garnering antics. As a young man in the late '60s, Kitano disappointed his parents by drifting away from engineering school to a series of menial jobs, culminating in the position of elevator operator at a Tokyo strip joint. He became intrigued by the wisecracking low comedians on stage and by the audience's raucous laughter. Soon he was up there with them, making with the one-liners, then paired off with another comic, known as Beat Kiyoshi. They played the nightclub circuit as a team, Tsuu Biito, the Two Beats (Kitano taking Beat Takeshi as his stage name), a Nippon Martin and Lewis for audiences of loud drunks and *yakuza* thugs wearing sunglasses at midnight. The Two Beats got famous on television, their edgy, deadpan schtick a hit with the young and hip. Kitano

then found solo success on an innovative, free-form variety show on TV, simultaneously becoming the king of all-night talk with a national radio program, where cruel wit and strong opinions on almost everything brought him a large and devoted following. He starred in *Takeshi the Genius' Happy TV Show!* and on a top-rated game show, *Takeshi Comedy Ultra Quiz,* overseeing viciously funny practical jokes and punishments. He once watched with amusement as the losers of a contest were locked in a bus and lowered into the ocean, where they began screaming in terror. As prankster or pontificator he fronted a different program every day of the week.

Kitano defied the standards for small-screen behavior. He was not genial, polite, or humble. He was mean, unpredictable, hysterical. Disciples gathered at his feet, a private army of aspiring comedians and devoted hangers-on. When a gossip magazine offended him, he led his troops in a violent attack on the periodical's staffers. His autobiography, *Takeshi-kun! Hai!* (*Takeshi! Here!*), a best-seller, of course, became a network miniseries.

In 1989 Kitano took the lead in a feature film titled *Violent Cop.* The great Kinji Fukasaku was set to direct, but left the project and the star took on the job. In the opening scene a defenseless old man is beaten and humiliated by a gang of schoolboys. One returns to his plush suburban home, followed by Kitano's Detective Azuma, who blandly slips up to the kid's room and slaps him bloody-faced. We learn in passing that the detective witnessed the beating of the old man and did nothing to stop it: in Azuma's world everyone has a job to do, sadistic brats and violent cops alike.

As a director of a violent crime film, Kitano showed no interest in fashionable Wooian pyrotechnics. A lung-busting chase after a bat-wielding maniac is cut to the music of a dreamy saxophone solo. Shootings and stabbings follow long silences or a quiet stroll. His second effort, *Boiling Point,* was even more idiosyncratic, a deadpan comic thriller that mixed *yakuza* violence and amateur baseball. A sluggish nitwit of a youth offends a hotheaded gangster and decides he must buy a gun to defend himself. This entails a trip to the outlaw-friendly resort island of Okinawa, where the boy and his pal meet a spectacularly and hilariously reprehensible *yakuza* gunman, played by Kitano himself. Key scenes are paced for absurdist payoff, long, static takes interrupted by the odd behavioral tic, a Laurel and Hardyesque effect of delirious inertia (the *temps mort,* Hal Roach used to call it). The deliberate, static style is also used for effect in the scenes of sudden, blunt violence. The director offered as influence the famous newsreel footage from Vietnam of a police chief shooting a prisoner at point-blank range. Kitano: "There is no movement in the camera, no up or down, but it's the most shocking thing I've ever seen. Violence is like comedy; it affects us suddenly, without warning."

For his third film, the surprisingly tender *A Scene at the Sea,* Kitano offered up another misfit hero, a deaf-mute garbageman who decides to become a surfer and gets a new lease on life before it is revoked by a very large wave. Kitano took the lead again in his next effort, *Sonatine,* the story of a luckless *yakuza* gang holed up at an Okinawa beach house. It was the seeming culmination of Kitano's distinctive style, with its lovably dreadful characters, the amazing dramatic shifts from humor to violence and back. The film was acclaimed around the world; though, as with all of his previous films, it was not a big hit at home.

Kitano had just finished shooting a sexy comedy called *Getting Any?* when, in the pre-dawn hours of August 2, 1994, an interrupted ride on a freshly purchased motorcycle resulted in his near-death and the paralysis of one side of his face. Out of circulation for months, leaving a series of gaping holes in the Japanese TV schedule, Kitano eventually reappeared in public in an eyepatch and with evident facial nerve damage. Making provocative comments about an "unconscious suicide attempt," he returned to work. Perhaps seeking to express their sympathy for the ornery media star, Japanese audiences finally turned out for a Kitano film, *Kids Return.* It was the story of two juvenile delinquents, Shinji and Masaru, classic Kitano underachievers. One becomes a boxer, the other an apprentice gangster; neither grabs the brass ring. The film is a withering portrait of dead-end lives. In previous pictures self-destruction had been an answer for his characters. Kitano's own recent experiences had caused him to change his views. The "Kids" are forced to go on at film's end. "Living," said Kitano, "is in some ways the harder choice."

Hana-Bi (*Fireworks*), his sixth film as a director, brought Kitano before the cameras for another lead role. The hyphenated Japanese title is a bit of wordplay: "hana," flower, a life symbol, and "bi," meaning fire, i.e. death. Matters of life and death, not to mention those

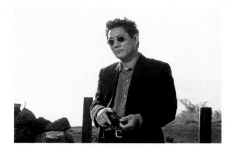

fireworks, surround Kitano's haunted hero, Detective Nishi. He quits the force to put the violent world behind him, only to find himself up to his neck in it when he turns to borrowing from loan sharks and, ultimately, robbing banks. Full of poignant silences and abstracted violence, it is Kitano's most austere and discursive film, and yet his most plainly emotional. "The film," Kitano stated, "is about the traditional Japanese spirit, which is dying out." The press said that the motorcycle accident had taken away some of the old harsh cynicism, and his TV fans did not know how to handle future prospects of a tender, loving Beat Takeshi. Trying to predict Kitano's next move was a loser's proposition, but it did seem likely that the old days of round-the-clock television work were behind him, leaving more time for motion pictures. Takeshi Kitano giving his full attention to the cinema? Considering the remarkable body of work he has already created while doing twenty other things at once, that is going to be something.

Takeshi Kitano as the troubled Detective Nishi in *Hana-Bi.*

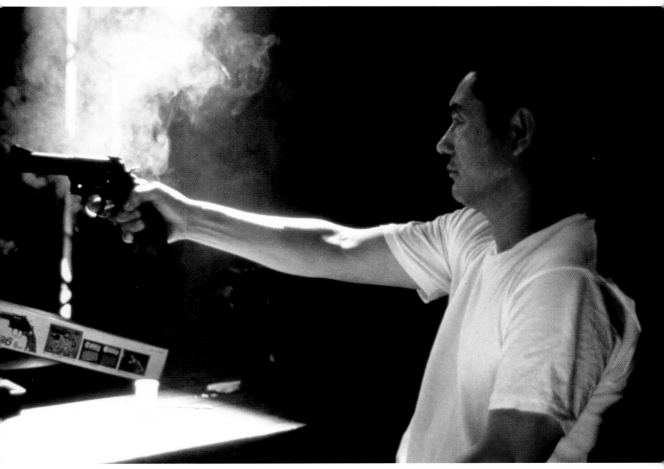

Takeshi Kitano in *Hana-Bi (Fireworks)*.

A N I M E

THESE DAYS, in any average well-stocked video store in America, the most well-represented—and in some cases the only—category of moviemaking from an Asian nation is the animated film of Japan. Too popular and broad in their appeal to be ghettoized in the lonely "foreign film" section, these tapes are stocked among Hanna-Barbera and Disney classics or, increasingly, given their own exclusive quarters, where *"anime"* lovers will not waste their time with antic displays of *Tom and Jerry.* Of course, the category of Japanese animation is itself a broad one, containing all variety of subject matter and approach, much of it exceedingly adult in nature. Thanks to ignorance of the *anime* world, and continuing American condescension toward cartoons as children's entertainment, parents haplessly set loose their *anime*-loving tykes on a vid store's selection of tapes that range from sweet fairy tales to nihilistic porn.

It is a very different situation from a decade before, when barely a handful of titles were officially available in the United States, and pioneering *anime* connoisseurs (affectionately known as *otakus,* Japanese for fanatics) depended on the samizdat network of fuzzy bootlegged dupes. America's *anime* consciousness expanded with the 1989 mainstream release of Katsuhiro Otomo's *Akira,* the powerful animated version of his phenomenally successful and longrunning *manga.* It's the story of soulless Neo-Tokyo, a bleak post-world war future metropolis and military dictatorship, home to brutal security forces, ruthless resistance fighters, and psychic bikers. Otomo and his team created an animated canvas of unprecedented and disturbing vivacity, and *Akira's* arrival on U.S. shores created a demand for similar fare.

Left: *Blue Seed:* It's cute teen special agents against bizarre, shape-shifting demons, the dreaded Aragami. The film's intriguing leading lady is Momiji Fujimaya, raped and implanted with an unborn Aragami's "blue seed," leaving her with psychic powers. Above: *Ai City:* The "Love City" is New York of the future, where psychic youths are pursued by big business bad guys. Blood splattering, violent, imaginative science fiction adventure with dazzling animation.

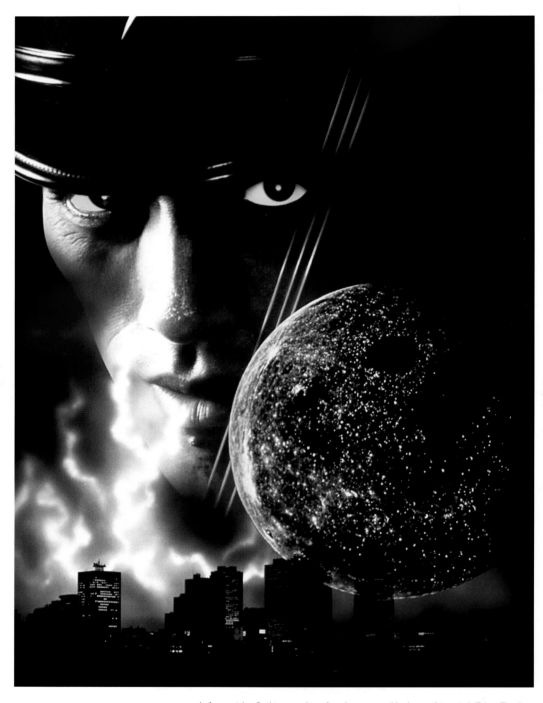

Left to right: Striking graphics for the memorable horror/historical *Tokyo: The Last Megapolis;* detail from *Blue Seed;* image from Osamu Tezuka's *Legend of the Forest,* an *anime* masterpiece. Without dialogue to increase its universality, set to the music of Tchaikovsky's 4th Symphony, *Legend* is a cautionary epic on the theme of environmental destruction; *Burn Up W* features Tokyo's curviest S.W.A.T. team, ready to do what it takes to fight terrorism, including nude bungee jump. Excellent fun for the lascivious of all ages.

Actually, Japanese animation had been a regular, if largely unacknowledged, fixture in American culture since the 1963 debut of Osamu Tezuka's television series *Tetsuwan Atom,* considerably better-known here as *Astro Boy,* the adventures of an emotional robot of the future. An even bigger success was achieved by *Speed Racer,* violent race car adventures, reruns still in circulation thirty years later. In 1969, *Astro*'s inventor, Tezuka, the Japanese Disney, created the first adult animation feature in his sumptuous production of *One Thousand and One Nights,* its sensuality—bare-breasted harem girls and such—anticipating the explicitly erotic features to come.

Animation prospered and matured in the '70s and '80s, in part as a direct outgrowth of the increasing variety and cultural importance of the *manga* from which so many *anime* works were directly adapted, and in part as a response to the raised stakes of American blockbuster competition: *anime* imagery could top the broadest Hollywood canvas at an affordable price. With an eager audience for these films—in some years they have accounted for more than half of all revenues from Japan-made motion pictures—*anime* could sustain as wide a range of subjects and

styles as the live-action cinema: cyberpunk sci-fi, historical epics, gentle animal stories, comedies, memoirs, erotica. Wispy pastel impressionism, the dense storybook look and anthropomorphism of the Disney features, slick hyperreality. For cinematic extravagance, no earthbound live film can hope to compete with the limitless possibilities of *anime*'s free-floating cameras climbing skyscraper walls or hurtling into space at will, and state-of-the-art sonics have given the films, especially in their big-screen engagements, the ability to totally envelop the viewer in their sensory spell.

Animation has for many years been the medium for some of Japan's most provocative and experimental filmmakers. The dramatic and emotional capabilities of *anime* were clearly displayed in Isao Takahata's *Grave of the Fireflies* (from Akiyuki Nosaka's autobiographical novel), the story of two orphans trying to exist in a firebombed city, a tender and devastating look at the toll of war on the innocent and defenseless. Similar subject matter could be found in *Barefoot Gen,* Keiji Nakazawa's account of a 6-year-old boy who experiences the bombing of Hiroshima. Variants of *Akira*'s dystopic noir vision are an *anime* mainstay, the greatest of them undoubtedly Mamoru Oshii's *Ghost in the Shell,* an adventure of the year 2029, all about a ferocious female cyborg chasing an evil terrorist in an epically rendered urban jungle. The film's dense swirl of narcotic imagery, high-tech inventions, Biblical allusion, philosophical ruminations, spectacular violence, and lush nudity made almost any live-action movie seem oddly one-dimensional.

One of the most acclaimed and beloved of Japanese animators is Hayao Miyazaki, whose *Nausicaa of the Valley of Wind* (given the more comfortable English title *Warriors of the Wind* and then butchered for U.S. video release) was a hauntingly beautiful fable about ecology, the power of love, and hope. The same director made the enchanting children's fantasy, *My Neighbor Totoro,* the story of two young country girls and their encounters with forest spirits and other odd entities. Miyazaki's evocation of an ethereal countryside, a Japan of quiet beauty that seemed to some no longer to exist, brought many an adult viewer to tears of nostalgia and regret.

Aimed squarely at an adult market are the many animated films featuring sexual themes, these ranging from the sunnily erotic to dark Sadean porno epics. The more extreme of the sexually explicit *anime,* known as *hentai,* have received a perhaps disproportionate amount of attention in discussions of Japanese animation, to the dismay of many *otakus* who have called *hentai* "the embarrassing brother-in-law of *anime.*" Still, it would be hard to ignore a work such as *Urotsukidoji: Legend of the Overfiend,* with its notorious rape scene, a schoolgirl violated by a phallic-tentacled demon. On an altogether lighter note are the many titillating and politically incorrect works from impudent and imaginative artists like Go Nagai, creator of the bodacious android *Cutey Honey* and tantalizing superheroine *Kekko Kamen* (*Something Else Mask*). The latter is a high school Wonder Woman who battles a fiendish school principal and his minions. Kekko Kamen wears a costume of red mask, gloves, boots, and nothing else, stunning opponents with a judicious flash of her naked private parts. Bosomy young women bursting out of scanty costumes are perhaps the single most prevalent figures in the *anime* world. Said Hideaki Anno, director of the *Neon Genesis Evangelion* series, "You've got to realize the animation industry is mostly a boys' club, so of course they're going to create something pleasing to their own eye. It's much more entertaining for us to draw large breasts than some wrinkled old face." Such creations were very convenient, Anno concluded. "Animated characters won't cheat on you or leave you for another guy."

Anime's growing impact on popular culture beyond Japanese shores is evidenced in the list of nearly 2,000 titles now licensed for American video release. The Disney organization's securing of the future work of Miyazaki (not to mention the curious history of *The Lion King*) and the Euro-American consortium financing *Ghost in the Shell* are further indications that *anime* is here to stay. In Japan, animation seems ever more ready to overwhelm "human" cinema entirely, with not only the animated films themselves filling theaters and video stores, but with an increasing percentage of live-action films adapted directly from popular *manga* and *anime* titles. In 1997, the Japanese animated feature *The Phantom Princess* (*Mononoke Hime*) became the nation's first and only $100 million earner, and by year's end overtook *E.T.* as the most popular movie of all time in Japan.

Based on the *manga* by Tetsu Adachi, *Weather Report Girl* is the amazing adventure of young Keiko, the strange, sexy replacement TV weather reporter whose striptease style brings big ratings to the network.

TOMOAKI HOSOYAMA'S *A Weatherwoman,* from an original *manga* by Tetsu Adachi, is an outrageous assault on all things holy and dignified: mass media, journalism, uniformed schoolgirls. The story of one gifted and uninhibited teenager's overnight rise to glory on network TV, *A Weatherwoman* is a fable of the boob tube in the tradition of *Network* and *A Face in the Crowd,* updated with enemas and masturbation. *A Weatherwoman's* real spiritual forebear is *Will Success Spoil Rock Hunter?,* with its glorious vulgar modernism; Hosoyama is worthy of comparison to Frank Tashlin, greatest of all comic hyperrealists.

Kei Mizutani, a big-eyed V-nosed *manga* heroine sprung to life, is Keiko, a pretty schoolgirl whose orgasms empower her to fly. Nabbing a one-time job as a weather reporter on the evening news, Keiko concludes her report by flashing her panties, sending the ratings through the roof. An instant superstar, the ambitious and mysterious teenager remakes the evening news into a garish spectacular with nudity and musical numbers. Meanwhile, Michiko, Japan's former weatherwoman, is now at her new job as street reporter for an exposé series called "Hello Pervert!", a position that becomes all the more humiliating when her first interview subject has a terrible accident on her head. Keiko is soon facing a more powerful rival in Kaori, the boss's daughter and would-be weather empress, and thus begins a spectacular battle for the hearts and minds of the gleefully worshipping public.

Slipped into video stores as just another *manga-* adaptation, *A Weatherwoman* found a second life in theaters, becoming a cult hit after well-received screenings at world film festivals (Kei Mizutani was given the 1997 Best Actress Award at Italy's Humor and Satire Festival). Hosoyama, who had apprenticed in low-budget "pink films" (*Sumo Wrestling Girls, Big-Milk Secreting,* and *The Lesbian Colony* among these early classics), then wrote and directed a semi-sequel, *Weatherwoman Returns,* with all-new characters and more over-the-top silliness, comely actress Misa Aika now playing the strangely talented weather report girl.

TELL ME ABOUT YOUR PINK FILMS.

My first job on pink films was as an assistant director when I was nineteen and a student at Nippon University. I learned everything about how to make films from working on these films. They are very low-budget, the film crews are very few, so you have to do everything I had been working as an assistant director for two years. I directed my first pink film, *Family Hooker,* when I was 21. I gathered funds from my parents, friends, or some money-lenders. That was about $30,000. After I completed my first film I sold all rights to a pink films distributor. Generally, pink films take three to four days to shoot without simultaneous sound recording, on 35mm. Running time is about 60 minutes. Pink films are screened at the theater all over Japan as X-rated movies. All pink films are softcore. So, I took four days to make my first film on 35mm with a complete script. Pink films are one of the few chances for young people who want to make their own films.

WERE ANY OF THESE PINK FILMS OF YOURS COMEDIES LIKE *WEATHERWOMAN* AND *WEATHERWOMAN RETURNS?*

On balance, my nine pink films were not comedies. Except for *Lesbian Colony.* This film was my homage to John Waters's *Desperate Living.*

ARE THERE AS MANY ARTISTICALLY INTERESTING PINK FILMS BEING MADE TODAY AS THERE WERE IN THE PAST?

Pink films started being made about thirty years ago in Japan. At first pink films were the resistance against the films made by

Left: Director-screenwriter Tomoaki Hosoyama. Below: The TV star and her fans, from *A Weatherwoman.*

major studios, using erotic images, but not hardcore. And pink films were the fortress to making films with advanced imagination for many independent filmmakers. In early years Japanese media paid attention to the "pink film movement" because many of the films took up some political subjects. But in the last ten years pink films have not gotten attention from the media, the public, and Japanese movie world. The first reason is that many Japanese do not like to see Japanese films today. They like Hollywood movies. The second is that adult video has become popular instead of pink films and "roman porno." Pink films and roman porno are a little different. Roman porno were made by a major studio, Nikkatsu. Pink films are made by independents. Adult videos are shot by Betacam and released only on videotapes, hardcore porno with "shading." In early years many pink star actresses were shining on the screen. They graduated from pink films to roman porno to major films or TV. And many Japanese directors of pink films graduated to bigger films, like Yojiro Takia, Banmei Takahashi, Genji Nakamura, Ryuichi Hiroki. Some pink films are presented in film festivals in Holland, Austria, Denmark, etc. Audiences in festivals consider pink films to be the cutting edge of Japanese independent films.

WEATHERWOMAN HAS SPECTACLE, MUSICAL NUMBERS, AND A VERY GLOSSY LOOK. HOW EXPENSIVE WAS IT TO MAKE BY JAPANESE FILM STANDARDS?

Weatherwoman cost $500,000. Each pink film generally costs about $30,000. But Japanese major films generally cost about $2 million. Weatherwoman is an independent film, and the budget is normal for that kind of film. The biggest problem was a lack of funds. Weatherwoman was shot in sixteen days on Super 16 system. It's very hard work. The crew was able to sleep for four hours a day during the shooting. In Japan it is very difficult for independent films to get a theatrical release. Weatherwoman was released on video but I made a 35mm print with English subtitles and sent it to the Stockholm Film Festival. Fortunately they liked my film and many other festivals offered to screen it. The news spread to Japan and then a distributor was interested in screening Weatherwoman in theaters in Japan.

IN YOUR FILMS MANY OF THE WOMEN ARE VERY POWERFUL AND THE MEN ARE ALL IDIOTS.

Major roles with strong females are not unusual now in Japan. Maybe modern Japanese women are more strong than ordinary men. In Japan today many men consider women difficult to establish relationships with. In many cases, women take the initiative. Kei Mizutani is

very similar to her role of Keiko in *Weatherwoman*. Kei is powerful, ambitious, patient, and erotic. She was a model, not an actress. I found her in the magazines. *Weatherwoman* was the first time for her to act. She was very confused. I directed her very strictly and she cried every day. But she did not give up. In the scene of being struck by lightning, Kei got burned on the hips. And the next day she acted without clothes in the bathroom scene. What part of her performance did she find the most difficult? Maybe all.

IS JAPANESE TELEVISION THAT CONCERNED WITH RATINGS AS IN AMERICA? AND ARE THERE ANY WEATHERWOMEN LIKE KEIKO?

Japanese commercial TV is very similar to America's. In Japanese television it is a very important thing how pretty the weather girls are.

AMONG OTHER THINGS, YOUR FILMS SATIRIZE THE CONVENTIONS OF JAPANESE PORN AND S&M MOVIES.

Yes. Generally, Japanese sex films that include enema scenes are very serious and gloomy. I wanted to have the audience laughing. The "Hello Pervert!" scene was the most fun to shoot. Ryuji Yamamoto, who acted as the Pervert, is a very talented actor. I think he is the Japanese Udo Kier.

DO YOU HAVE A THEME YOU ARE TRYING TO CONVEY IN YOUR WORK?

The theme is "nonsense." Nonsense about mass media, love affairs, about life and the real world. To sum up, the things that are meaningful are composed of nonsense.

Left: Kei Mizutani and Yasuyo Shirashima, battling media stars in *A Weatherwoman*. Right: Kei Mizutani as the schoolgirl who flashes her way to fame in *A Weatherwoman*.

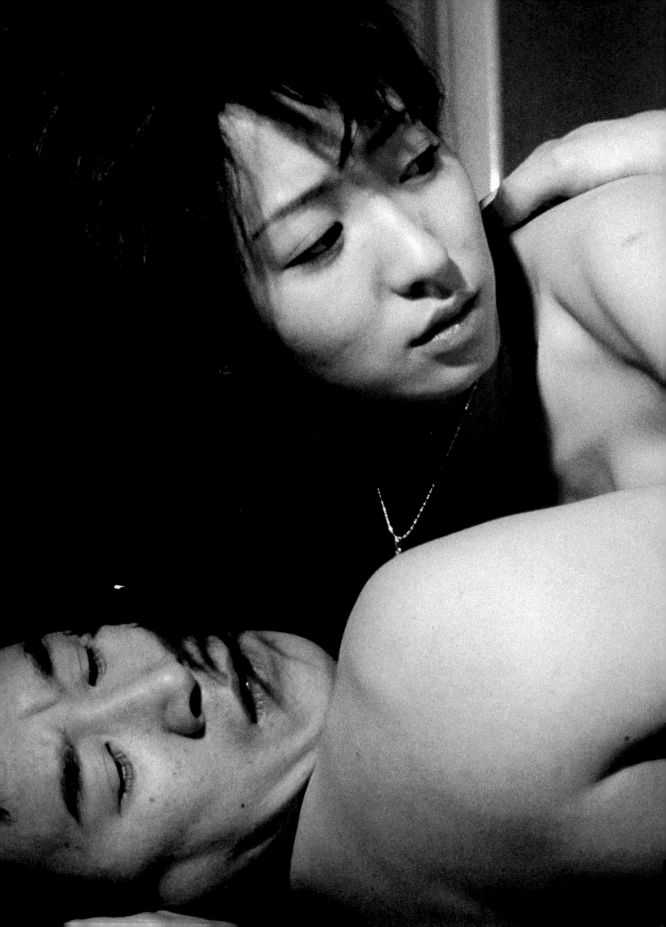

KOREA

KOREAN FILMMAKING REMAINS at this writing one of the world's better-kept secrets, though for more than ten years the country has been producing distinctive and original movies in great number. A combination of changing laws regarding domestic production and critical shifts in government in the 1980s led to great new opportunities for creative expression, including an unprecedented independent film movement. The arrival of directors such as Hong Sang-Soo, Jang Sun-Woo, Kim Young-Bin, and Park Cheol-Soo made Korea's place among the world's great national cinemas difficult to deny. Meanwhile, the "discovery" of early works by veteran moviemakers like Im Kwon-Taek (with more than 100 titles to his credit) and a truly intriguing "lost" genre wild man named Kim Ki-Young, indicated the distinct possibility that Korea had been turning out fascinating features all along.

The first Korean-made films were exhibited in 1919. A commercial film industry of sorts existed throughout the rest of the silent era, though it was said to be amateurish in the extreme. Actors were paid with rice, up to one bag per film according to how good a performance they gave, and a talented performer, with regular employment, was known as a six-bag-a-year man. Silent thespian Yoon Bong-Choon recalled that there *were* non-glutinous compensations, as performers got to "ride to film openings in fine rickshaws, to be entertained after the show with the most beautiful *kiesang* girls in Korea." Japan's brutal colonialization of the country effectively stamped out the native movie business until the end of World War II (not without subsequent

Left: Another film about sex and food: *301/302*. Right: Bang Eun-Jin as a divorcée with an attitude in *301/302*.

quid pro quo repercussions, notably a ban on public exhibition of Japanese films in effect for more than half a century).

The war with the North proved to be another setback, and it wasn't until the late '50s that Korea's homegrown product began to thrive, with low-budget action pictures for the men and weepy soap operas for the women. Government censorship was a problem and would increasingly come to castrate the film business during the seventeen-year tenure of the dictator Park Chung-Hee, when only anticommunist propaganda and harmless entertainment, including countless kung fu films, would escape the censor's scissors. The strongman was assassinated in 1979, replaced by martial rulers who continued to restrict the scope of local filmmaking. These regulations were finally lifted or liberalized in 1985, leading to an upsurge in the production of unusual and adventurous films and the emergence of many exciting new talents.

Even before the late '80s new wave movement, director Im Kwon-Taek had demanded serious critical attention with his 1981 release *Mandala*. Kwon-Taek had been making films since 1962, mainly crime and swordfighting pictures. Fed up with these "quota quickies," he became determined to create something more substantial. His career was reborn with the adaptation of the controversial novel by Kim Song-Dong, a tale of two unorthodox Buddhist monks traveling through modern Korea. Imbued with Kwon-Taek's very large heart, *Mandala* explored matters of transcendence with a matter-of-fact—and very effective—simplicity. The first of his films to deal with aspects of the Korean spirit and psyche, the nature of his countrymen before the dilutions of Japan and the West, it was followed by such acclaimed works as *Daughter of the Flames* (a dramatization of the continuing influence of shamanism) and *Sopyonje* (a tale incidentally about a kind of traditional Korean blues music and the loss of indigenous folk culture). But Im Kwon-Taek had not completely turned his back on the sort of hot-blooded genre work that had kept him busy for twenty-plus years: his *Son of a General,* and two sequels, were stylishly violent period (1920s) gangster flicks, with echoes of *Once upon a Time in America,* lusciously designed crime dramas about local gang lords battling their Japanese rivals for street supremacy.

Left to right: Illustrating Korea's growing cosmopolitanism, *Deep Blue Night* was about a "green card marriage" between two alienated immigrant yuppies, filmed entirely in the United States; *End of Autumn,* Kim Soo-Young's bittersweet love story of a female murderer and a gangster on the run was the first Korean film to receive international acclaim when it was released in 1966. It was Kim Soo-Young's 100th feature; a lively look at Korea's frisky young people, Dong-A's *Do the Right Thing.*

Looming over all other candidates as the most provocative of the new film-makers is Jang Sun-Woo, a man whose caustic viewpoint, political engagement, and stylistic experiments have brought comparisons to '60s film revolutionaries Oshima and Godard. Beginning with his first film, the social satire *Seoul Jesus* in 1986, his films have addressed a variety of hot topics, from sexual abuse (*To You from Me,* with its startling animated sequence), to Korea's capitalist ethic (*Age of Success*), and self-satisfied intellectual class (*The Road to the Racetrack*), and Buddhism (in the allegoric road movie *Hwa Om Kyung*). In *A Petal,* Jang dramatized one of the most explosive events in modern South Korean history, the massacre at Kawngju in 1980, when the military, under the directions of President Chun Doo-Hwan, slaughtered more than a hundred civilian protesters. Jang had dreamed of dramatizing those events from the time they occurred (his own concurrent activism resulted in his arrest and torture). In *A Petal* he used horrifying documentary footage of the massacre as a kind of prologue for a densely layered story of a young girl survivor's adventures, orphaned by the violence, a victim of sexual exploitation, a symbol of the country's history of abusing its own people. The director's edgy staging of sex scenes caused some to question whether the film itself wasn't exploitative of the performers—not the last time Jang would hear such complaints. More recently he filmed—and apparently abandoned before completing—the compelling pseudo-documentary *Timeless Bottomless Movie,* a raunchy, in-your-face tour of glue-sniffing teen low-lifery. The media gossiped about his demanding direction, about the sex scenes, the on-location injuries to cast members, and one actress's nervous breakdown. Whatever toll it took, the result of Jang's cinematic experimenting was a uniquely fascinating film world.

Above: From Hong Sang-Soo's *The Day the Pig Fell into the Well.*

In a country looking back at a century of exploitation and repression, Jang is far from the only politicized filmmaker with a desire to expose the sins of the past. In the powerful *A Single Spark,* director Park Kwang-Su recounted the stirring true story of Jeon Tae II, the martyr of the '60s union movement who self-immolated to protest the inhumane conditions in the country's factories, and "sparked" a nationwide labor movement. Going back to the horrors of World War II, Byun Young-Joo's *Murmuring* was a devastating documentary exploration of the tragedy of the "comfort women," Korean females forced into battle-zone prostitution to service the Japanese troops. Byun located six of the former sex slaves who were willing to let her camera enter their lives and their memories, with disturbing results.

Other filmmakers have chosen more contemporary subject matter: life among the newly materialistic "democracy generation" and late-breaking developments in the battle of the sexes. Hong Sang-Soo's brilliant *The Day a Pig Fell into the Well* follows a quartet of characters in present-day Seoul, a Woody Allenish comic-dramatic roundelay of novelists, precocious young women, and adulterers. The director had four screenplays written, in-depth portraits of the main characters, then wove parts of each into a single shooting script, resulting in a film as detailed and natural as real life. Sexual politics, a subject of great interest to many modern Koreans, has been dramatized in such well-received films as the ruminative *Three Women on the Road* and the more incendiary *A Hot Roof,* about a rooftop standoff by a group of women who have just killed a wife-beater. A different—bizarre—take on women's problems appears in Park Cheol-Soo's *301/302,* a fiendish, deadpan black comedy. In the adjacent apartments of the title, two women live contrastingly troubled lives: 301 (Bang Eun-Jin) is a manically depressed divorcée who distracts herself with nonstop gourmet cooking; 302 (Hwang Sin-Hye) is a reclusive bulimic. Flashbacks provide glimpses of the men in their lives and other nightmares, squalid arguments, sexual humiliations, a fricasseed puppy, incest. The two women develop a strange relationship that leads to a grotesque but mutually supportive climax. Here's your blurb: *The Odd Couple* plus cannibalism.

Of course, the majority of Korean films are less subversive fare—simple action movies, melodramas, and romantic comedies, though even in conventional modes the local filmmakers have distinguished themselves: Kim Young-Bin's cops 'n' robbers hit *Terrorist,* with the old plot about brothers ending up on opposite sides of the law, was as kinetic and blood-drenched as the most exciting product from Hong Kong. More exciting still are the prospects of unknown— at least in the West—talents resurrected from the Korean cinema's utterly obscure past. The Second Pusan Film Festival tribute to a certain 78-year-old director named Kim Ki-Young brought to light a renegade hack whose transgressive, over-the-top B movies—*Killer Butterfly, The Housemaid, Iodo,* etc.—with their panoply of witch doctors, necrophiliacs, female rapists, and, yes, killer butterflies, set an unprepared audience's eyes afire. Subjects for further research indeed.

Poster for Park Cheol-Soo's *301/302.*

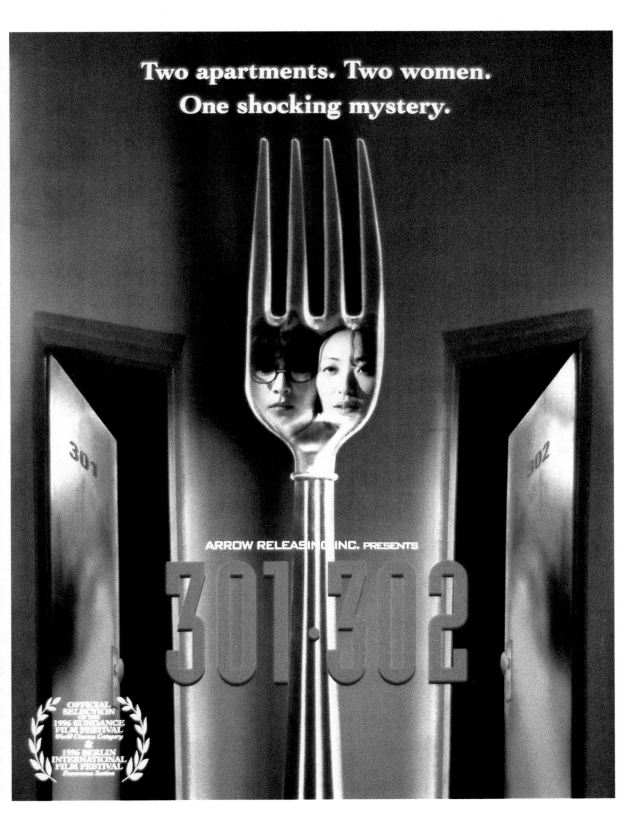

JOHN R
A

PHILIPPINES

WORLD AUDIENCES ARE well-acquainted with the Philippines as celluloid landscape in Western-made films from *Apocalypse Now* to assorted drive-in epics about topless young women in prison. The country's own cinema, however, remains for the most part uncharted territory to outsiders. The haphazard evidence to be gleaned from scattered festival screenings and untranslated tapes in ethnic video stores indicates a lively, if low-budgeted, film world; raucous, sentimental, at its best a compelling mixture of raw pulp energy and socio-political consciousness. While most of the films produced are unapologetically lowbrow or exploitative, there is a vein of genuinely populist filmmaking, and even some otherwise escapist movies in the Philippines commonly address the hopes and frustrations of the underclass. In fact, cinema and society are totally entangled in the spirited, contentious democracy of the post-Marcos Philippines, where even the making of the popular *bombas* or STs (Sex Trips), the cheap local erotic movies, becomes a virtual political crusade, beset by attacks from church, state, censor board, and citizens' groups.

A LOCAL ENTREPRENEUR named Jose Nepomuceno established the first Filipino movie company in 1917. His initial feature film, *Country Maiden,* displayed astonishing creativity. The orchestra accompanying the film in the Manila theater was the same orchestra seen in the film, and they and a female singer also featured in the movie performed in live synchronization with the musical numbers on the screen. Thus Nepomuceno's theater was the site of the world's first sync-

Poster for Regal's *Moises,* a blood 'n' guts action drama.

sound motion picture, and perhaps the world's first interactive mixed-media event as well. The Philippines established a thriving film industry by the 1930s, with its own big studios and contract star system, a primitive emulation of the Hollywood tradition. Partly for political reasons, most films were shot in the Tagalog language, and, according to veteran filmmaker Eddie Romero, the Philippine movies were what helped consolidate Tagalog as the national language.

War closed the industry down for several years. When filmmaking resumed it was a busy free-for-all of small companies and one-man-bands, all turning out a narrow mix of genre fare, melodramas, comedies, and adventure stories on miniscule budgets. The films were widely criticized for their patently unreal stories and primitive technique and hyperbolic style. Pure pulp ruled on the local screens throughout the 1960s and '70s, a lurid array of bloody Tagalog westerns after the spaghetti model, sub-007 spy movies, martial arts action, violent war movies and *bombas*. Producer-director-writer Eddie Romero, who began scripting films as a teenager before the war, created Hemisphere Pictures to make action movies for international release, importing minor American stars like Burgess Meredith (*Man on the Run*) and Jock Mahoney (*Walls of Hell*). Romero's were cheap B pictures—his *Beast of the Yellow Night* cost $50,000—sold for U.S. double bills and drive-ins. "But by local standards they were epics," Romero says. "They required much higher standards for the technical aspects." The speed and economy with which Romero filmed panicked his U.S. distributors. "They were sure there would be no 'coverage' to edit the film properly. They couldn't believe I was shooting less than 90,000 feet for a 90-minute feature. But I thought I was being rather profligate. I could have made *three* pictures with that much film!" In the '70s, Romero became associated with that ultimate drive-in studio, American International Pictures, for whom he directed the lurid action classic *Black Mama, White Mama*, a gender switch on *The Defiant Ones* with Pam Grier and Margaret Markov as the frequently bare-breasted escaped prisoners.

The local pulp cinema was held in contempt by the educated and upper classes, and the fans of the woefully cheap action and horror movies were disparaged as the "bakya crowd" after the type of wooden clog shoes worn by peasants in the provinces. Columnist A. Roces hectored snootily, "The bakya crowd is not so much a matter of class distinctions as a certain mentality. . . . They watch a violent movie where the hero shoots down seven men with six bullets, seated in a bedbug-ridden, knife-slashed seat, their feet on the backrest, cracking peanuts and repeating loudly every line said on the screen."

Inevitably, the movie business harbored a few renegades with a desire to elevate the assumedly sub-basement artistic level of the local productions. In the '70s, a series of unusual and provocative films appeared by ambitious young, or newly inspired old, directors and writers: Lino Brocka, Ishmael Bernal (his urbane films were the first to turn the cameras on Manila's bourgeoisie), and veteran Eddie Romero (who turned his back on U.S. connections to make *This Is The Way It Was . . . How Is It Today?* a comic historical tale that explored aspects of Filipino identity through the adventures of a Candide-like innocent).

Lino Brocka, who had worked as a director in the theater and had apprenticed with Eddie Romero on his coproductions, was a film buff weaned on Cagney and Garfield gangster movies. He wanted to make Filipino movies that would have the same emotional impact,

social awareness, and technical sheen as those old Warner Bros. classics. He began slowly, not rocking the boat, with adaptations from the komiks, the popular fumetti or adult comic books, mostly soap operas in content. His first feature, released in 1970, was a weepy melodrama titled *Wanted: Perfect Mother.* By the mid-'70s he was making films like *Manila, in the Claws of Neon,* a tale of two lovers eaten up by the mean streets of the capital city, with a more than implied criticism of social inequities and an uncaring government. Brocka's portrait of Manila as a sweating, sensuous film noir hell made it a sister city to Welles's *Touch of Evil* bordertown or the Manhattan of Siodmak's *Phantom Lady.*

Jaguar, the first Filipino film shown in competition at the Cannes Film Festival, put the Philippines on the cinema's world map. With a brilliant screenplay by journalist and political activist Jose Lacaba, *Jaguar* realized Brocka's dream of a relevant, hard-hitting gangster film in the Garfield/Cagney tradition. It told the tale of a building security guard who becomes mixed up with a rich businessman and his seductive wife, and the blood-soaked downward spiral that ensues. The film pulsed with anger, the sense of a society simmering with hostility, ready to boil over and scald everything in sight.

The irony of the Filipino film renaissance was that it got underway even as dictator Ferdinand Marcos was beginning his reign of brutal repression, imposing martial law in 1972. Marcos tossed dissenting artists and journalists into detention camps. Future screenwriting wiz Ricky Lee went to jail for a year, Lacaba for two years, and even the established Brocka spent many weeks behind bars for political offenses. And yet, deepening the irony, these and other obvious opponents of the dictator's abuses became mainstays of the Filipino film biz in the Marcos era. It was an uneasy alliance. Madame Dictator Imelda in particular loved a good movie, and favored the making of modern, intelligent films that might get critical and public endorsement in the outside world. The Marcoses established a ministry to fund worthwhile projects; they hosted an annual international film festival and built the Parthenon-like Manila Film Center. But the kind of realistic and tough films the best directors and writers created appalled the Palace. Imelda was particularly disturbed by depictions of poverty on screen. She demanded Ishmael Bernal change the title of his *Manila by Night,* claiming the sordid locales in the film could not possibly have been filmed in her country. Movies were routinely censored and often banned outright. When the Marcoses got a last-minute look at Broca's *Jaguar,* they threatened imprisonment if the Cannes screening was not stopped. The film festival importuned an attendee, Sean Connery, to fire off a cable to Imelda, saying how much he was looking forward to seeing Brocka's new work; the ban was quickly lifted, Mrs. Marcos thrilled to accommodate her new pen pal.

Brocka, a skilled filmmaker in demand by the big studios, began turning out commercial movies—action, erotica, melodrama. But he continued to make socially conscious films all through the Marcos regime, films like *Bayan Ko: My Own Country,* challenging the government edicts against "negative" depictions of the land or the people. He found independent sources for financing these harder-hitting films and, inevitably, some were banned. Brocka told historian John Lent, "It was like a tug of war: to make some movies I like to make, I'd make one that would be a sure box-office success. . . . When I made five a year, four would be commercial and one that Marcos would not like, that would enrage Imelda." Even with the studio assignments,

The sumptuous Rosanna Roces.

Brocka and frequent collaborator Jose Lacaba tried to add a touch of social criticism, however sub rosa. Their *Angela Mercado,* a film noir adaptation of a komiks "ripoff" of *The Bride Wore Black,* showed a working-class waitress being raped by a gang of aristos and getting nothing but abuse from the police. When the victimized "angel" decides to take justice into her own hands, tracking and killing her upper-class rapists, the symbolic message was barely disguised.

An oblique evocation of life under martial law, but more notorious for its unabashed eroticism, was Peque Gallaga's surreal, outrageous *Scorpio Nights.* Gallaga's answer to *Last Tango in Paris* or Oshima's *In the Realm of the Senses,* the film was an almost abstracted lust triangle about a dim security policeman, his bored, horny wife, and a lascivious young student, living cheek by jowl in a scummy, crumbling apartment house, residences—and lives—separated only by a layer of holey plywood. Critics called it pornography. "I wanted to see if I could delineate character simply through behavior and etiquette in bed," Gallaga said of the film. "It became a story of sexual obsession, of perversity, and of one-upmanship; there being no rewards except for the sex itself." Sex leads to violent death, in a chilly nihilistic ending absent moral judgment. Gallaga: "The point is that the whole exercise becomes a contest to see who can . . . cross the line. After a while, death becomes the line and you cross that line at your own peril." Gallaga's erotic scenes are intense and varied, including some memorable saliva-swapping, sex through a floorboard, and a hint of necrophilia, the almost continuous couplings filmed with a lip-smacking Jess Franco-like enthusiasm, camera restlessly prowling the humid set, squinting through peepholes and skulking on the floor for a vermin point of view. Set in the Biondo district of Old Manila, *Scorpio Nights* evokes a neighborhood of wet rot, where the residents alternate between two states of mind, rage and arousal. The film had nearly half its running time taken away by the censors before it could open in Philippine theaters, and still played to shocked capacity crowds.

AFTER THE DICTATOR and his well-shod wife were deposed, the artistic community began to assert itself with renewed strength. But the filmmakers found that chaotic democracy brought with it a new set of problems and petty despots, church leaders, politicians, and government-appointed and self-appointed censors of the left and right. Peque Gallaga, of Spanish descent, complained of a backlash—in the name of Filipinisation—against whites and Chinese in the industry. Meanwhile the strong influence of the Catholic Church in the Philippines ensured a constant battle against

the celluloid sinning going on in the immensely popular softcore sex films, which every week seemed to elevate a new bar girl or ex-stripper to Queen *Bomba* status.

Although for a time the Philippines ranked among the world's ten most active film centers, production gradually tapered off in the face of competition from Hong Kong and Hollywood and with the rise of videotape. Producers have long complained about the video piracy business, which makes new theatrical films available on bootleg tapes within days of a premiere. Some are taped with a camcorder inside the movie theater, and as a result may include the outline of other audience members' heads, à la *Mystery Science Theater 3000*. After laying low for a while,

Diliryo, passion-soaked melodrama from Peque Gallaga, director of the notorious *Scorpio Nights*.

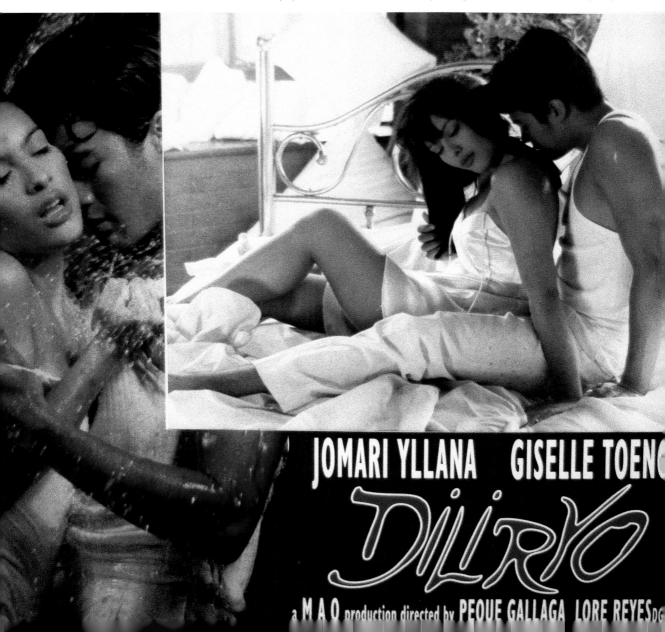

JOMARI YLLANA GISELLE TOEN

Diliryo

a M A O production directed by PEQUE GALLAGA LORE REYES

the *bombas* have returned in force in recent years, considered the only type of local production that can be guaranteed to turn a profit. The content of the so-called "bold" films was ostensibly kept in check by a censorship squad called The Movie and Television Review and Classification Board (MTRCB), but *bomba* producers would cleverly *re-insert* the scissored scenes at individual theaters, resulting, in turn, in police raids. Allegations that MTRCB agents accepted bribes—VCRs, fax machines—for giving some Sex Trips a free pass, caused a congressional inquiry. One eagle-eyed crusader denounced the film *Patikim ng Pinya* (*Let Me Taste the Pineapple*), which was screened with censored inserts put back, including "frontal nudity and lewdness lasting for three to five minutes. . . . What is worse," he concluded, "is that such salacious scenes have no connection at all to the overall story and can be done away with without disturbing the plot." That the *bomba* audience would be less disturbed to have the plot done away with than the frontal nudity did not occur to the outraged citizen.

Lino Brocka died in 1991, but his legacy of provocative filmmaking has lived on in the work of associates like screenwriters Jose Lacaba and Ricky Lee, and such directors as Mel Chionglo and Tikoy Aguiluz. The most impressive Filipino films in recent years have been in the Brocka style, entertainment mixed with social consciousness. These populist films address dilemmas known to many in the audience. Often inspired by true stories, they portray ordinary Filipinos thrust into melodramatic situations in their struggle for survival or a better life. In Aguiluz's *Segurista,* the screenplay by Lacaba and Amado Lauesta, a provincial married woman, Karen (played by the stunning Michelle Aldana, former Miss Asia Pacific), leaves her home in Pampanga, a region devastated by *lahar* (volcanic mudslides), for better prospects in Manila. She becomes an insurance agent by day, a hostess/hooker at a lurid karaoke bar by night, the two jobs melding as she gives pleasure to her daytime clients and sells policies to her johns. The film skillfully mixes moods, veering between humor, eroticism, and tragedy, intercutting orgasmic liberation and Catholic guilt. *Midnight Dancers,* from the director/writer team of Chionglo and Lee, told a similar story but in the world of Manila's gay go-go bars, where three well-made brothers prostitute themselves to support the family roost and their selfless mother. As the boys' dangerous half world destroys them, *Midnight* ponders the price of survival in a corrupt world. "Everyone's a whore these days! Teachers! Actors!" the film's one female hooker screams as the police bust her. "To whom can we turn? The cops? The politicians? We can only help ourselves!"

Midnight Dancers was banned in the Philippines. *Plus ça change* as they say in Brooklyn. . . . Long delayed from opening was the hard-hitting *Sarah Balabagan Story,* directed by Joel Lamangan, with Vina Morales playing the title role. Another true story, it dramatized the horrifying experiences of a Filipino teenager from a poverty-stricken home who is sent to work as a housemaid in one of the Arab Emirates. When her employer's father tried to rape her, Balabagan knifed him to death. Sentenced to be executed, the young girl became a cause célèbre in the Philippines, where she personified the tens of thousands of Filipinos forced by circumstances to seek menial work overseas. Lamangan's blunt, powerful docudrama brought on a hailstorm of protest before it could even open, from the government worried about ruffling Emirate feathers to people's groups concerned for the welfare of other Filipinos in Middle Eastern countries to Moslem spokesmen complaining of the film's racist stereotyping. Considering the tempest that

surrounded almost every adventurous film, it had to take balls of steel for moviemakers like Lamangan not to throw in the towel and start making Tagalog westerns again.

A discussion of the populist Philippine cinema should not be concluded without a few words for its reigning goddess, the charismatic, fascinating Rosanna Roces, whose tumultuous personal life bears much in common with her on-screen characters and with the experiences of many of the poor and working-class moviegoers who adore her. Of mixed German-Filipino parentage, Roces was left for adoption as an infant, in her early teens dropping out of high school and drifting through a series of odd jobs. According to *Filipinas* magazine, "The temptation of money lured her to a classy nightclub called Pegasus, where she worked as a GRO—'Guest Relations Officer,' a euphemism for prostitute." She broke into the movies, rising from bit parts to leads in a series of "bold" films (such as the aforementioned *Let Me Taste the Pineapple,* in fact) that featured her in various states of undress. Her candor and wit in defending her earlier life brought her to the attention of director Carlitos Siguion-Reyna, who cast her as Legaya ("Joy") in *Call Me Joy,* the story of a lovable prostitute who longs to get away from her small-town brothel. A naive farmer falls for her and takes her away, but life in the straight world isn't all she dreamed it would be, where her future father-in-law is a rapist and the local priest is one of her old tricks. Sadder but wiser, Leyna returns to the whorehouse. Critics were startled to admit that the "Titillating Film Queen" had given a stirring performance, created a character of depth and emotional power. Roces on-screen was a "joy" to behold, a mesmerizing presence with the warmth and earthiness of the pre-code Jean Harlow plus a touch of Kim Novak's sullen mysteriousness. The erotic *Call Me Joy,* with its "antisocial" message, attack on the clergy, and nudity, looked ripe for banning, but the popularity of Rosanna Roces, particularly among Filipino women, and an ensuing letter-writing campaign kept the film from becoming another victim of the rabid government censors. The film was released with remarkably few cuts, signaling to some the beginning of a new era of artistic freedom. The people—or at least Ms. Roces's fans—had spoken.

Filipino movie goddess Rosanna Roces, former "Titillating Film Queen."

EDDIE

RO **M** ERO

A REMARKABLE FIGURE in Philippine film history, Eddie Romero entered the movie business as a teenage screenwriter in the years before World War II. He became a director in the postwar era, shooting Tagalog-language movies, a language he did not yet actually speak (he judged line deliveries by the actor's emphasis and rhythm). Throughout the '60s and '70s, Romero shot B movies, horror and action mostly, exporting them to America's drive-ins and grindhouses: gritty, violent war films like *Walls of Hell* and *Manila, Open City,* and exploitation classics like *Black Mama, White Mama* and *Mad Doctor of Blood Island.* While working as a production coordinator for Francis Ford Coppola on *Apocalypse Now,* Romero determined to return to making movies for his countrymen. Which he has done, with a series of colorful and thought-provoking films, stories exploring aspects of Philippine history and identity: *This Is The Way It Was, The Eagle, The Day before Yesterday.* In 1997, fifty-six years after his first script was produced, Romero was busy preparing an intriguing new series for television.

PHILIPPINE CINEMA BEFORE THE WAR The studios had been in business for three or four years when I started. They were very primitive, with very old equipment. But they had already established a star system like the Hollywood studios, and there were a number of stars who were box-office insurance. The movies were aimed at the masses, the very poor who would

Director Eddie Romero and Mrs. Romero, on location.

spend everything they had to watch a movie. But the producers were all of the rich and middle class, and they had no idea what people wanted to see. They were poor imitations of American Academy Award-winners, mostly melodramas—Loretta Young-type movies. They had no idea that people in the lower culture level might not understand them or that they wouldn't appeal to them.

BECOMING A DIRECTOR Jerry DeLeon said, "You'll never make a living as a writer, become a director." I said, "I don't know anything about directing. I don't speak Tagalog, and the words I do know are unprintable." He said that not knowing anything about directing is no big deal because nobody else knew anything. We learned from sitting in the theaters, watching other movies. So, in '47, I directed my first picture.

THE DRIVE-IN ERA Pam Grier was the gamest actress I ever worked with. She was willing to do anything—jump off a cliff, whatever! I'd be talking to a stuntwoman and Pam would say, "Oh, I can do that!" Ha! *Black Mama, White Mama*—that film wasn't half bad. There are scenes in there I wasn't ashamed of . . . but some of those "cult" films, *Beyond Atlantis* and *The Brides of Blood Island,* the worst things I ever did! . . . Ayy . . . !

APOCALYPSE NOW Coppola was a very interesting personality. He kept saying, "Don't ever call me a professional. I'm an *amateur*." Now, give an amateur $30 million and see what happens! He wanted to use real bodies in the scenes. I put the kibosh on that. He wasn't thinking of the details. It was just, "Wouldn't it be great to have some *real corpses* hanging from there! Get the bodies from the funeral parlors." I said "No way. We have great sculptors, we'll put them to work on it." Besides using real corpses being against the law—*I could go to jail!* Then they go back to Hollywood and say, "My God, what a corrupt society!"

MOVIE MAGIC We were shooting *The Day before Yesterday* on location and there were so many problems. A storm swept away our set and other things. We lost our generator. It was impossible to shoot our night scenes. I said, If we could just have one good night! A local woman said, "Mr. Romero, have you talked to the shaman? What have you got to lose?" So we talked to the shaman. He made an offering to the god. The shaman said, "Okay, you shoot on Saturday." We got there. The sky was clear, the stars were out. We shot. I said, "That's a wrap" and we loaded all the equipment into the trucks. And then it rained, poured down in buckets. Later, I learned it had been raining all night everywhere but that little spot where we filmed.

FILM AND POLITICS Lino Brocka would say to me, "How can you hang around with these Marcos people! What do you want from them?" I'd say, "Nothing." Lino and I had different ideas of how to live with evil. There is a great deal to be lost in taking black-and-white positions. We got Lino out of jail a few times. He didn't mind me, but Joseph Estrada was part of the establishment. And Lino turned around and cried—he couldn't deal with his enemies coming to help him. And Joseph really pulled strings to get him out. Just because Lino was in the movies. That made him family. You see, we movie people are a tribe here.

JOSE

LAC **A** BA

INTERVIEW

JOSE "PETE" LACABA is the renaissance man of Philippine cultural and political affairs: award-winning poet, translator, teacher, editor and reporter, crusading columnist, political prisoner (he spent the years 1974–76 at Camp Crame, thanks to the generous support of the Marcos regime), and one of the key figures in modern Philippine cinema. As a screenwriter and collaborator with director Lino Brocka on five films, beginning with *Jaguar* in 1979, and as the writer of such recent productions as *Escapo, Segurista,* and *Rizal sa Dapitan,* Lacaba's name is attached to many of the significant Philippine films of the last twenty years.

YOU GOT INTO THE MOVIES THROUGH JOURNALISM?

 I used to write movie reviews for the *Philippine Free Press.* I did reviews and interviewed people in show business. I was interested in writing for the movies but I never got around to doing it. At the time Marcos declared martial law I had been doing a lot of political writing. In '72 our newspaper was closed down and I went into hiding for a year and a half and then in '74 I was detained for two years. A political prisoner. No charges were ever filed, but it was basically for my journalism. When I got out there were no publications willing to use my stuff. So I went back to trying some non-sensitive subjects. I decided to do an interview with the film director Ishmael Bernal, an old friend who also used to write movie reviews. And he said, "I know you're interested in movies; why don't you do a script for me?" And

Above: Jose Lacaba. Right: Michelle Aldana in Lacaba's *Segurista.*

that's how it began. And Lino Brocka was somebody I knew back when he was still in the theater. So I gave Lino a storyline. Anyway, that was how it got started.

THERE WAS STILL MARTIAL LAW—DID THE SCRIPTS GET CLOSELY SCRUTI-NIZED BY THE GOVERNMENT?

Yes. Before martial law, in that period, the movie industry barely ever used scripts. They just worked with outlines and the directors improvised scenes and the actors improvised their lines. These were westerns, karate movies, James Bond type of movies, whatever the trend. And exploitation movies like the *bombas*, and some melodramas. Most were close to improvised. It was said that the scripts were written on napkins and the backs of cigarette boxes. Lino was somebody who wanted a real script, and then when martial law was declared it became a necessity to have a script before shooting so they could be controlled. Before you would even write a script you would submit the storyline to the Board of Censors, and they tell you if you will be allowed to write the script, and then you submit the script to know if you will be allowed to film it. The government made scripts a requirement before you could start filming anything.

SO IN A WAY MARTIAL LAW HELPED ESTABLISH THE SCREENWRITING PRO-FESSION!

Yes, that's true! Government created jobs. Anyway, there was a lot of censorship, but that became part of the game.

THE FIRST SCRIPT YOU DID WITH LINO WAS *JAGUAR* IN '79.

I cowrote it with Ricky Lee. I gave Lino some storylines. I thought of adapting an article about some gang wars, a teen gang war story about somebody from the working class getting involved with some rich kids and taking the rap for them. But Lino had in mind an actor who wasn't a teenager: Phillip Salvador. He's a big star now but he was unknown at the time. So we tailored it for him, made the hero a security guard. We wanted to do an action story with some noir elements, and I guess some elements about society came into it. There were scenes about the slums, and supposedly they had ceased to exist with martial law. So when it got invited to the Cannes Film Festival the government tried to stop it. It was more Imelda than anyone. And then she got a letter from Sean Connery in Cannes and she couldn't say no to him. I think that letter was also the reason Imelda set up the international film festival, shortly after this, so she could meet people like Sean Connery.

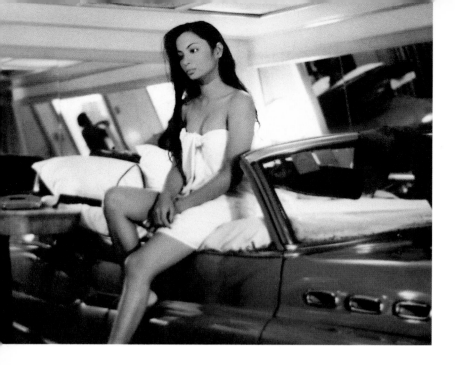

If you make box-office movies the producers allow you
every now and then to do more personal projects. And also Lino went to find
additional financiers outside the movie industry—businessmen, lawyers,
bankers. With Lino I did two very commercial films, *Experience* and *Angela
Mercado.* The latter one was a popular comic book serial, the fastest script I
ever wrote. Lino started shooting before I had even finished, so every day his
production manager came to the house to pick up what I wrote. I never even
had a copy to look at. They took the pages right from my typewriter. It was
shot in sequence because of that. From script to the end of filming was no
more than two weeks, three weeks. The comic book serial was still running
and the writer sent word of how he intended to end the story. I think we gen-
erally ignored it. She kills off everybody and actually we didn't show her
being caught, but we were required by the censors to say she had been
caught, in an epilogue.

THE KOMIKS WERE A REGULAR SOURCE FOR FILM STORIES THEN?

Yeah, because they were very popular, the most popular
medium before television made inroads. These were not like American style,
with Batman and Superman. Mostly melodramas and some horror stories.

Above: Michelle Aldana in *Segurista,* 1996. Photo courtesy of Neo Films. Right: A dra-
matic moment in the life of *Segurista*'s insurance agent/prostitute heroine. Directed
by Tikoy Aguiluz.

It's not entirely by choice. I have done a lot of commercial scripts also. But I have been typecast, they get me for these projects. The films based on true stories, with some social elements, are the films that generally get some attention. With films like *Segurista,* we are working in very popular formats, TFs [Titillating Films], sex films, whatever, and trying to give them a more serious treatment.

She had disappeared, and a detective found a black book listing her clients and other details. She sold insurance for sexual favors. It was just the premise that the director found interesting. And at that time he had shot some documentary footage on the Pampanga, the area that was destroyed by volcanic eruption. So we incorporated that and then did a lot of research on the nightclub scene. It was a representative situation, because there are so many people in the Philippines, including schoolteachers, professional people, who must leave home, leave the country, to find any kind of work. They work as maids in Hong Kong, entertainers in Japan.

It is an important theme here. And a popular one: the provincial coming to the big city and working as a prostitute, doing what they must to survive. It was a favorite theme of Lino's, and Bernal did a lot of films on this theme, *Manila by Night* and others. And there was *Midnight Dancers.*

Yeah, the same. *Midnight Dancers* had more men. Actually, it's a criticism made about Tagalog movies, that they're all about gangsters and prostitutes. With a film like *Segurista* we're using the commercial formula but trying to approach it with more realism and seriousness. But the film got some flak from some feminist reviewers who thought the portrayal of women was not entirely flattering.

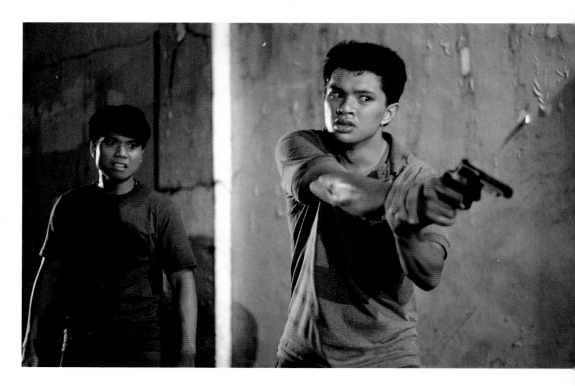

THERE'S ALWAYS A LOT OF COMMOTION ABOUT THE *BOMBAS*.

Yes, they're very popular again, but now they are called ST's—Sex Trip movies. Some writer said they are saving the movie industry because they are popular and they are made very cheaply. The budget might be five million or seven million pesos. Some of the big studios set up dummy corporations to make these. There was one setup where the idea was to make the film from beginning to end in seven days. And some interesting films got made by new directors, experimental, in the search for new formulas.

The rules on paper are very strict. You can show one bare breast but not two. So the censors cut everything out of the movie.

These are called "bonus scenes." Full frontal nudity and penetration. They put them back in or run them at the end of the movie, all the outtakes, the cut scenes. The censors have caught on and there have been a lot of raids, theaters closed down. If you pay off the right people you can get away with a lot of things. The censors are often more concerned with serious films that tackle sexual subjects or have some adult material than the formula porn stuff. *Segurista* got an X rating, as did *Schindler's List*.

When Lino was making movies we thought the breakthrough was imminent because of the festival attention. At one time we were exporting our action films to places like India, Pakistan, the Caribbean. I was surprised when I was in Pakistan that they were showing Tagalog movies in the theaters. Now there are some coproductions with Hong Kong people. Perhaps the situation will change for the better. I wish I knew.

Above: A hot night in a Manila go-go bar, from *Midnight Dancers*. Left: Alex Del Rosario settling a score in Mel Chionglo's *Midnight Dancers*.

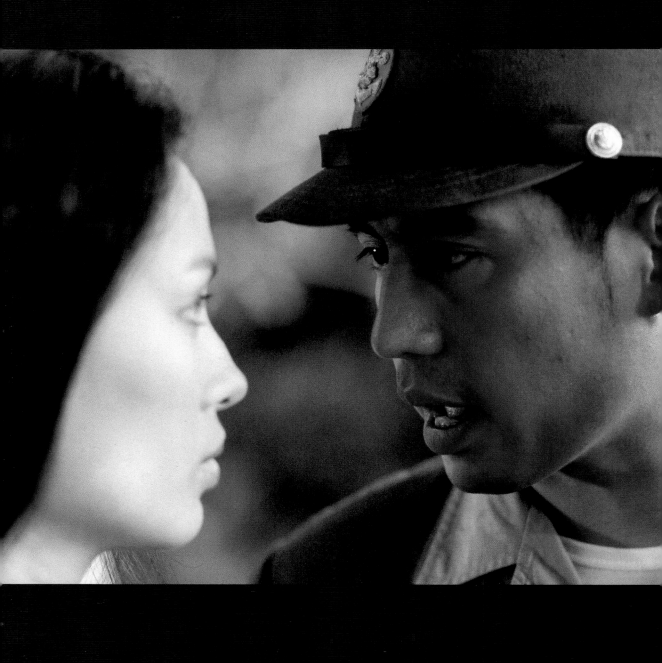

SOUTHEAST ASIA

TELEVISION, CHEAP PIRATE videos, and the overwhelming competition from expensive foreign imports have curtailed the demand for local film product in much of Southeast Asia. A once bustling industry in Indonesia was reported to average fewer than a dozen native productions per annum in the last few years. Most of these films were aimed at the loyal exploitation market share, those cinephiles who can still be lured away from their TV sets by titles like *Nocturnal Desire* and *Erotic Black Magic*. Filmmaking in Malaysia seemed headed in the same direction, where the local production companies gave up chasing the coins of theatrical audiences and turned their attention to hour-long video dramas for the burgeoning satellite TV business. *Variety*'s Baharudin Latif reported that only one group of native motion pictures thrived in the country, teenage love melodramas, a fad spawned by 1993's *First and Last Lover*, and followed by similar teen soap operas: *Love's Grief, The Fate of Love, Love in the Dust*. While Hollywood and Hong Kong ruled the other genres, in affairs of the heart young Malaysians still demanded hometown role models.

Thailand too has seen a gradual drop in local production. In the 1960s the country released 200 and more films a year, pure entertainment efforts along the Indian model. The number has dwindled to a few dozen per year of late. Young people are the most reliable audience, reflected in the number of movies about teen romances, often starring current pop-music stars. Hopes of a reinvigorated film biz were raised by the arrival of multimedia companies interested in making movies. Grammy Film, run by Euthana Mukdasanit with the assets of an extremely

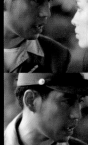

Grammy Film's *Sunset at Chaopraya*, the Thai *Gone with the Wind*.

successful record company behind it, produced the sumptuous *Sunset at Chaopraya* (*Khoo Kham*), a Southeast Asian *Gone with the Wind* set at the time of the Japanese invasion during World War II.

Among the most accomplished and certainly the most idiosyncratic of Thai filmmakers is Prince Chatri Chalerm Yukol (not the only titled royal among local auteurs, by the way). A maverick independent, financing his own films, specializing in crime and lowlife subjects and with a taste for shocking images and daring camerawork, Prince Chatri might be dubbed "the Thai Sam Fuller." After training to be a geologist, he studied cinematography in the U.S., returned home to work in television for a time, then directed his first film, *Out of the Darkness,* about extraterrestrials landing in a primitive village, Thailand's premiere science fiction movie. His second film, *Dr. Khan,* dealt with government and police corruption, risky business with a military strongman then in office. To thoroughly research his third production, a tale of young Bangkok prostitutes, he lived in a brothel for six months. Perhaps his best-known film until recently was *Citizen,* a violent variation on *The Bicycle Thief,* the story of a taxi driver who loses his car—and with it all his dreams for the future—to a gang of bandits.

Working as his own cinematographer, Prince Chatri's films are studded with imaginative and occasionally awesome visual dynamics. *A Gunman* contains a shot worthy of comparison to the famous one-take robbery in *Gun Crazy:* a subjective viewpoint shot (filmed by the director) from the back of a motorcycle, pulling up to a hotel, continuing on inside the building, into a coffee shop, killing a man, then retracing the route back outdoors, all without a cut. In *Powder Road,* he investigated his country's drug trade, from the cultivators in rural Chiang Rai to the seedy smugglers sent out of Bangkok. In the film's most startling sequence, a female impersonator has a bag of smack surgically implanted in his breasts. "I was working with this transvestite," Prince Chatri told interviewer Thomas Richardson of his inspiration. "And I wondered, was it possible to put it into his tit? The answer is, it is possible! You can put one-half kilo into each of a woman's tits and walk undetected. If you have a true transvestite, he can carry at least two kilos of heroin."

After many tries, the Prince had his first certified smash hit with the 1996 release *To Deplore,* another dynamic gutter drama, this one about a quartet of teenaged girl prostitutes.

The country of Vietnam has produced a steady stream of films in recent years, only a few finding their way to outside exhibition. Director Ho Quang Minh's *Gone, Gone, Forever Gone,* the 1996 official entry for the American Academy Awards' foreign prize, was an epic-scaled story of a Buddhist nun (a former concubine) caught between two brothers fighting on different sides in the years of the civil war. The film received mixed reviews, critics decrying its belabored pace and poor performances.

More welcome was the work of an artist-in-exile, the vastly talented Tran Anh Hung, who left his war-ravaged home at the age of four, growing up in Laos and France. He returned to Vietnam in preparation for his first feature, *The Scent of Green Papaya,* but ultimately shot the entire movie on a hermetically sealed Parisian soundstage. The title refers to a characteristic aroma of prewar Saigon households, for the director a symbol of everyday life in that long-gone world. *Scent* observes the daily routine of a sweet-natured servant girl, Mui, and the family for which she works, the placid surface of everyday lives concealing private tragedies and longings.

A sudden leap forward in time brings Mui's story to an unexpected and enchanted conclusion, a coda of mysterious, transcendent beauty. With an elegantly gliding camera, lushly evocative decor down to the last rippling mosquito net, and a Dolbyized sonic wash of tropic atmospherics, Tran created a pristinely exotic dream of Saigon.

With his second film, *Cyclo*, he would have the real city at his disposal, a teeming, crumbling hothouse of a city filled with sweat, kink, and sudden bloodshed. *Cyclo* is the story of a young fatherless pedicab driver falling in with a criminal gang run by a crafty widow; his sister meanwhile lured into prostitution by a troubled hoodlum/pimp, a fallen angel known only as The Poet. Where *Scent* was contemplative and sly, *Cyclo* is passionate and explosive, a film about loss of innocence and the price of corruption disguised as a violent, phantasmagoric gangster movie. The director-writer's years at the Sorbonne's philosophy department are evident in a web of carefully contrived symbols and allusions (fish, blue paint, nosebleeds, etc.) and in The Poet's free-verse voiceovers. But Tran, despite himself, is most powerful with moments of pure cinema, the orchestration of sound and image: scenes like the brutal rooftop knifing of the sadist, staggering to death, the camera floating along overhead; and the haunting sequence in the disco, Radiohead's "Creep" pulsing from the speakers as gorgeous Tran Nu Yen Khe, dancing in handcuffs, awaits her next client while her lover/procurer Tony Leung-Chiu Wai cringes with self-loathing, a remarkable commingling of sensuality and voluptuous despair, one of those rare movie-movie moments that make time stand still. The Viet authorities were said to be unhappy with Tran's lurid depiction of their metropolis. If they had any sense they would be giving him the keys to the city—here was the filmmaker to put them on the map.

Tran Anh Hung and Tran Nu Yen Khe, the director and the star of *The Scent of Green Papaya* and *Cyclo*. Photo by Robin Holland.

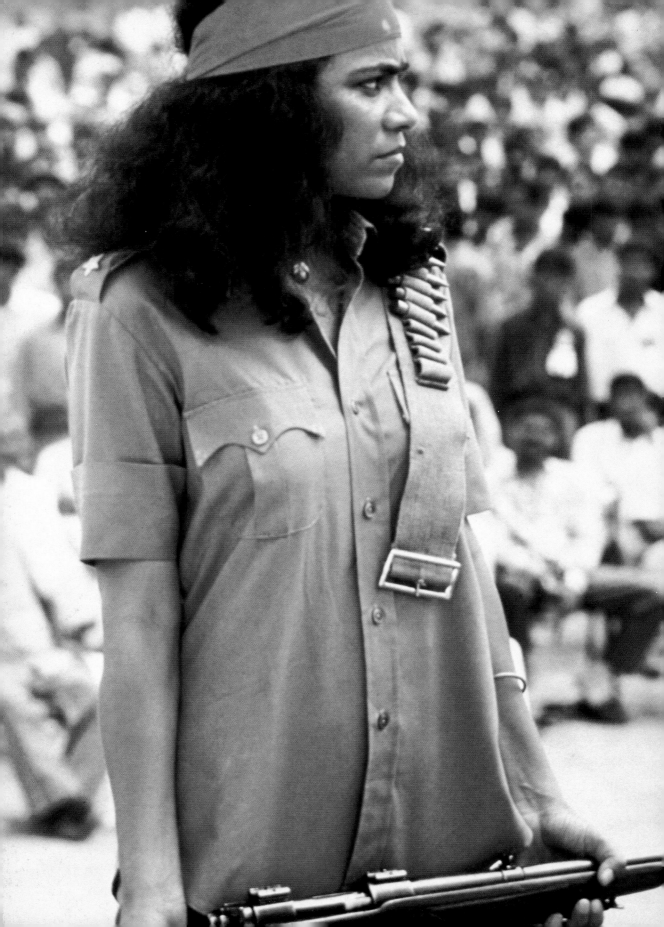

INDIA

I SAW MY first Indian movie in an art deco palace in Bombay. The film was in Hindi and unsubtitled, of course, but it was relatively easy to follow the plot. I had, after all, seen something with a rather similar story and cast of characters called *Dirty Harry* (unofficial remakes, I would learn, were not uncommon in subcontinental cinema). The hero was chunkier than Clint Eastwood and had much more hair, but possessed the same tight-lipped demeanor and disdain for civil rights. Where the film veered away from the Don Siegel-directed *policier* was when the hard-as-nails Indian cop began lip-synching to a tinny playback recording of a pop song and then cutting loose with a self-possessed dance number a bit reminiscent of Ann-Margret's choreography in *Viva Las Vegas.* Eastwood had done *Paint Your Wagon,* of course, and the results had not been pleasant, but there was no comparison with the disconcerting spectacle of the previously dignified Bombay inspector jerking and frugging his way across the screen.

My negative reaction was born of ignorance, and with time I came to realize that I had just then been introduced to the multidimensional world of *masala cinema,* where tears, gunfights, slapstick, politics, cloying flirtations, and sudden go-for-broke musical sequences flowed together as one. This uniquely Indian brand of entertainment is the last vestige of the days when movie-going was an event, an all-night, bring-the-whole-family affair, recalling a time in America when a ticket got you a double feature, newsreel, swing band short, cartoon, and perhaps some free dishes. But the *masala* movies put the whole cinematic vaudeville into a single sprawling

Left: Seema Biswas as Phoolan Devi in Shekhar Kapur's *Bandit Queen.* Right: Phoolan Devi meets her fans in *Bandit Queen.*

entity. What is more, they do it *ad infinitum,* with as many as 100 new features completed every month of the year. India has long been the most prolific film producing country in the world—in the history of the world—turning out up to 1,000 pictures a year.

The first Indian feature film (without British participation) was Dada Saheb Phalke's *Raja Harishchandra,* in the spring of 1913. An industry was up and running by the early '20s. Unlike many other Asian nations, India started making sound features early and exclusively, beginning in 1931. The technical facilities—soundstages and more elaborate equipment—demanded by sound encouraged the consolidation of big studios—Bombay Talkies, New Theater, Ranjit, and more—many of which followed the Hollywood pattern with contract players, assembly-line production, and control of theater chains. Like much of the rest of the world, India experienced a great depression in the '30s. Countless numbers of rural peasants drifted into the cities in this period. To entertain and take the rupees from this huge, uneducated mass, the studios crafted busy, colorful, circus-like movies, with simple, repetitive stories and archetypal characters—the *masala* was born.

The Indian art film came to life in 1955, when the 34-year-old Calcuttan Satyajit Ray released his first film, *Panther Panchali,* the story of the Bengali boy Apu and his simple rural village. It was a production that had nothing at all in common with the Bombay studio extravaganzas. Influenced by the neo-realism of Rossellini and DeSica, Ray used an amateur cast and crew. Shooting on weekends, raising expenses by selling his possessions, he worked on the film for three years, completing it with the help of a local government grant (spurred by an endorsement of the rushes from John Huston). It would become one of the most celebrated films of all time. *Panther* and two subsequent companion pieces, *Aparajito* and *World of Apu,* formed the "Apu Trilogy," three films of raggedy beauty, poetic expressions of Ray's profound humanism.

Another Bengali realist, Ritwak Ghatak, less widely known but considered by some to be Ray's artistic equal, followed on the heels of *Panther Panchali* with *Ajantrik* (*Man and the Machine*), an acclaimed dramatic satire of a Chota Nagpur villager's obsessive love for his 1920 Chevrolet. Many of Ghatak's subsequent films would be hard-hitting dramatizations of political issues and civil unrest in Bengal. His *Subarnarekha* is a brutally powerful look at life after partition and an indictment of caste prejudice. Brother and sister and their untouchable friend head for the big city, sister becomes a hooker, propositions brother, and then kills self, the untouchable friend torn apart by an angry mob—a gut-wrenching downer.

Maya (Indira Varma) and Tara (Sarita Choudhury) get wet in *Kama Sutra.* Left: Another scene from Mira Nair's erotic extravaganza, *Kama Sutra.*

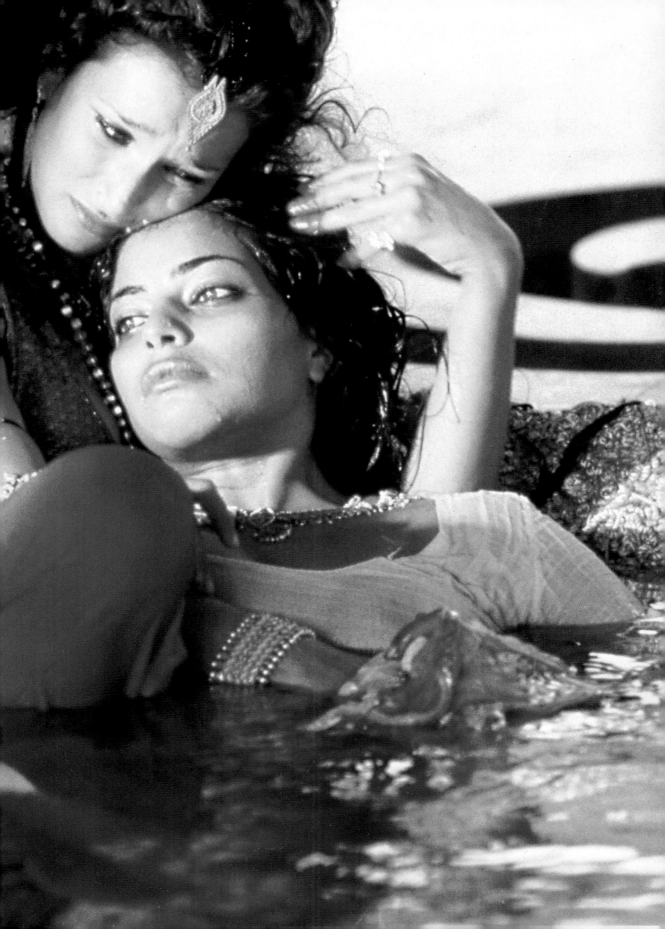

Poster for Jaydev Thackeray's *Sapoot.*

Escapist cinema became more entrenched and, adding color, more popular than ever from the 1960s onward. The star system was an integral part of the industry. Indeed, it would eventually overwhelm the studio system that created it. Today's massive, ever-expanding army of Indian heartthrobs and screen goddesses operates largely under a free-for-all of floating production connections and seasonal associations, making performing in twenty or more movies per year an even more chaotic prospect. The Indian public loves its movie stars, those residents of a semi-mythical kingdom known as *Bollywood,* the passion-soaked environs of Bombay (Mumbai), capital of Hindi filmmaking. Bollywood is like a gaudy dream or a cartoon of golden age Hollywood, the Hollywood that might have been conjured up in the fever-wracked mind of a Louella Parsons, or maybe a Philip K. Dick. Stars seem to be ever-swirling about town in stretch limos and sports cars, spewing glamour, the women glowering in wraparound shades and silk saris, the men leering above their *Saturday Night Fever*-styled suits, on a frantic commute between film sets and adulterous love affairs.

Left to right: *Aur Pyar Ho Aaya:* a colorful Bollywood production; a "lovable love story," from India; Nitin Raj's *Daava,* directed by Sunil Agihotri.

A long string of colorful publications reports on the movie colony's every move, magazines like *Filmfare* and *Stardust,* the pages densely packed with caustic gossip and impertinent interviews in which the reporter might accuse the star of giving bad performances or fooling around with her/his leading man/woman ("Yes!" cries Sanjay, "I am whole-heartedly denying my so-called 'little something' with Madhoo!"). Often the interviewer goads the subject with irritating small talk (*Filmfare:* "Apart from rumours about her new improved nose, there have been whispers that recently she also went in for breast enhancement surgery. 'Are you mad?' Shilpa bristles.") or quotes from a rival star, provoking a torrent of intemperate comments (The beautiful Ashwini: "Yes, I have walked out of *Chikni Chachi.* And it is because of the disgusting attitude of Mr. Kamal Hassan. My blood boils when I have to talk about that man."). The magazines make a guilty pleasure with their goofy single-mindedness and a prose style that often seems to ape the effete scurrilousness of Kenneth Anger in his classic work, *Hollywood Babylon.*

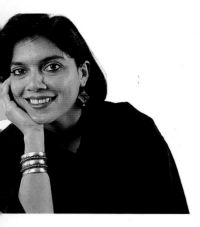

The films themselves are entertaining to be sure, if often indescribably weird, full of beautiful starlets, with much singing reminiscent of the vocal stylings of Yoko Ono. Here, a sampling of recent Bollywood releases:

BOMBAY. The film takes on the bitter events of partitioning. Sweet Manisha Koirala and swain Arvind Swamy decide to split from their peaceful village and elope to the big city. Unfortunately, Bombay is in the throes of civil unrest, with Hindus and Moslems rioting in the streets, atrocities aplenty committed by both sides. With singing.

GUPT. A rarity for Bollywood—a murder mystery. When the powerful Governer is assassinated, everyone thinks it the work of his stepson, handsome Saahil, just because the kid had tried to kill him many times before. Saahil escapes prison through a toilet conveniently perched over the ocean, and begins a search for the real killer. Lots of irritating song and dance interludes with a lush-figured Manisha Koirala shimmying as if her life depended on it.

ZIDDI. The plot is terribly complicated, the movie just plain terrible. The violent son of a respected lawyer alienates his family, the police, the local criminals. Filled with shootings, stabbings, assassinations, human fire bombs, and some wonderful musical sequences. Alternating between self-styled Robin Hood, psycho killer, and spirited dancer, the hero causes pain and anguish for everyone, especially the audience.

I LOVE INDIA. *Dishum dishum* (action flick) with a nationalistic slant. The adventure thriller stars the popular Sharat Kumar as the officer investigating terrorist activity in unstable Kashmir. The trail of illegal arms takes Sharat to the Western deserts, where the terrorists promptly bury him in the sand. Along the way, the rugged hero sings, dances, tells jokes.

IRUVAR. A political drama based on an amazing true story of movie stardom and politics in Tamil Nadu. A film actor and a screenwriter vie for political power; the star forms his own party but his demagoguery is stalled by death. Fascinating docudrama.

Mira Nair, director of *Salaam Bombay* and *Kama Sutra*. Photo by Robin Holland.

KOYLA. A young wife married to a mean old husband falls for his deaf and dumb slave. She gets caught and the dumb lover is killed but a miracle brings him back to life and restores his speech. He goes back for his girlfriend and kills the husband and his henchmen. Starring the beautiful Madhuri Dixit and superstar Shahrukh Khan as the mute, the film is a brutally violent drama, filled with rape scenes, revealing the growing exploitation factor in recent Indian films. Shakrukh is India's DeNiro with a penchant for odd and antihero roles.

RAJA HINDUSTANI. A poor taxi driver, Aamir Khan, falls for a rich girl, Karisma Kapoor, but her family objects. He woos her with songs and free rides. Kapoor, a second-generation Bollywood screen goddess (her mother is '70s superstar Babita) is perhaps the most enticing of Bollywood's countless ravishingly attractive leading ladies.

OH DARLING, YEH HAI INDIA. Kehtan Mehta is one of the most respected directors of the "parallel cinema" for films like *Mirch Masala* and *Bhavni Bhavai*. Of late he has moved into the commercial realm with kooky projects like this one, a slaphappy *Prisoner of Zenda* comedy-drama about a fiendishly clever bad guy with plans to take charge of the nation. He creates a clone of the President of India that he swaps with the real thing, then undermines the government by causing riots in the streets. Lots of dancing.

While the art and antics of Bollywood capture the attention of the majority of Indian ticket buyers, other, less frivolous films do get made in the so-called alternative or parallel cinema, films without any singing or dance numbers whatsoever. Shekhar Kapur's magnificent *Bandit Queen* told the real-life story of Phoolan Devi, a child bride, raped and exploited, falling in with a gang of rural outlaws, eventually becoming their ruthless and mythic leader, waging war on evil land barons and the men who did her wrong. Kapur directs the early scenes of abuse and humiliation with a cold relentlessness, chillingly evoking a world without pity. His scenes of action are also tough, with plenty of kinetic impact, as in the bandits' daylight attack on a defenseless town. Kapur obviously had an entire community at his disposal, the camera craning across rooftops and sweeping down streets as Phoolon and her men wreak vengeance. *Bandit Queen* was abruptly banned for "bad language, adult themes, and blatant nudity." Indian films were traditionally chaste, but increasingly filmmakers were eager to break the bonds of the censors. Commentators in the press decried the wave of "art films" trying to bring "smut" to the movie screens. But soon even Bollywood filmmakers were trying to push the envelope: some playful frottage in *Karan Arjun,* a glimpse of bare bosom in *Gangster.*

Two films, both the work of women directors with international reputations, gave the moral watchdogs their greatest fights to date. Mira Nair, from Bhubaneshwar and Harvard University, has always courted controversy in her Indian films: *India Cabaret,* a documentary about the lives of cabaret dancers, criticized for its eroticism; her controversial documentary *Children of Desired Sex,* on the topic of pregnant women and the premium placed on male children; and her brilliant international success, *Salaam Bombay,* featuring the taboo subjects of child runaways and prostitution. Returning to India after two American-based projects, she made

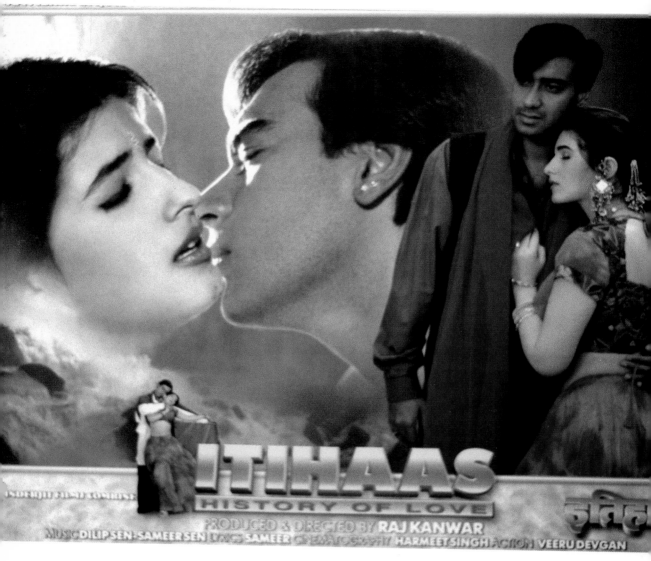

ITIHAAS
HISTORY OF LOVE
PRODUCED & DIRECTED BY **RAJ KANWAR**
MUSIC DILIP SEN · SAMEER SEN LYRICS SAMEER CINEMATOGRAPHY HARMEET SINGH ACTION VEERU DEVGAN

From producer-director Raj Kanwar: *Itihaas, History of Love.*

A scene from Deepa Mehta's controversial *Fire*.

1997's *Kama Sutra,* a sumptuous and sexy historical drama using the ancient erotic manual as an "inspiration." Attempting to celebrate the "philosophy of love," the director stated, "I wanted to make a film about an era when sexuality was not taboo—a film that explores natural sexuality." Set in sixteenth-century India, the film tells the tale of Maya (the enticing Indira Verma), a voluptuous servant girl, and her tumultuous relationships with a promiscuous king, his frigid wife, and a studly sculptor. Along the way to true love and tragedy, Maya becomes the most accomplished and athletic courtesan in the land. The film worked best as a wonderful re-creation of Hollywood epics of the '50s, sort of *Land of the Pharaohs* with pubic hair, and was beautifully designed, photographed, and scored. Indian censors demanded forty cuts, including the elimination of each and every nude scene, and all references to such ancient intercourse techniques as "twining of the creeper" and "the cobra." Nair went to war, proclaiming, "When a film is unabashedly and proudly about sexuality and sexual politics between men and women, you cannot cut out the sexuality . . . you are ripping up the whole film." The censors dug in their heels.

The heated battle over *Kama Sutra* had barely cooled when another film caused an equal or greater conflagration: Deepa Mehta's *Fire,* the first film from the subcontinent to address the subject of lesbianism. Given its premiere at the International Film Festival of India at Trivandrum, the screening resulted in a near-riot. Hardly exploitative, Mehta's film incisively examined the state of gender politics in its story of two wives with unloving husbands. The threads of family and convention that hold their lives together slowly unraveling, the women are ultimately drawn into a sexual relationship. Said Mehta, "It was amazing that a film which explores choices, desires, and the psyche of people who are victims of tradition would cause such an uproar." This time the defenders of an offending film were as noisy as the attackers. *Fire,* an artfully provocative and important work, was the perfect test case for those who believed India was ready for a more progressive, less restricted cinema.

BOOKS:

Baker, Rick and Toby Russell. *The Best of Eastern Heroes.* London: Eastern Heroes Publications, 1995.

Buruma, Ian. *Behind the Mask.* New York: Pantheon Books, 1984.

Cowie, Peter, ed. *Variety International Film Guide.* Hollywood, CA: Samuel French, 1996.

Desser, David. *Eros Plus Massacre.* Bloomington, IN: Indiana University Press, 1988.

Hammond, Stefan and Mike Wilkins. *Sex and Zen & A Bullet in the Head.* New York: Fireside, 1996.

Lent, John. *The Asian Film Industry.* Austin, TX: University of Texas Press, 1990.

Logan, Bey. *Hong Kong Action Cinema.* Woodstock, NY: Overlook Press, 1996.

Mullen, Joan. *Waves at Genji's Door.* New York: Pantheon, 1976.

Ramachandran, T.M. *70 Years of Indian Cinema.* Bombay, India: Cinema India-International, 1985.

Rayns, Tony. *Seoul Stirring.* London: ICA, 1994.

Richie, Donald. *The Japanese Movie, rev. ed.* New York: Kodansha International, 1982.

Silver, Alain. *The Samurai Film.* Woodstock, NY: Overlook Press, 1996.

Tucker, Guy Mariner. *Age of the Gods.* Brooklyn, NY: Daikaiju, 1996.

Weisser, Thomas and Yuko Mihara Weisser. *Japanese Cinema.* Miami, FL: Vital Books, 1996.

Yang, Jeff et al., *Eastern Standard Time.* New York: Houghton Mifflin, 1997.

PERIODICALS:

Various issues: *Filmfare, Stardust, Asiaweek, Cinemaya, Tokion, Giant Robot, Filipinas, Film Comment, Cineaste, Cinema India-International, Variety, Animerica, Asian Eye, She, Asian Trash Cinema, Asian Cult Cinema, Oriental Cinema, Kinema Jumpo, Hong Kong Film Connection.*

FOR FURTHER INFORMATION:

A.D.V. Films. Website: www.advfilms.com (*Anime,* Gamera, and more)

Arrow Releasing, 135 West 5th Street, New York, NY 10020 (Non-theatrical 35mm showings of *Bandit Queen* and other titles)

Asian Video Movies Wholesale, Danesh Kumar, Marketing Mgr., 685 Lansdowne Avenue, Lower Level, Toronto, Ontario, Canada M6H 3Y9. E-mail: asianv@messagebox.com (Wide array of Indian/Bollywood features, theatrical and video distribution)

Chambara Entertainment at (213) 687-8262 or by mailing to 708 West First Street, Los Angeles, CA 90012. (Zatoichi series on video)

Criterion Collection/Janus Films. Website: www.criterionco.com (High quality editions of classics new and old)

First Run Features at 1-800-229-8575. Direct mail sales. (Unusual selection of foreign titles)

Home Vision at 1-800-826-3456. (Classic and contemporary Japanese titles)

Regal Home Entertainment, 390 Swift Ave., S. San Francisco, CA 94080. (800) GO-REGAL. Website: www.regalfilms.com (Specialists in Filipino films)

Tai Seng Video Marketing, 170 South Spruce Ave., Suite 200, S. San Francisco, CA 94080. Toll free 1-800-888-3836. Website: www.taiseng.com (Official distributor for hundreds of Hong Kong videos, lasers, etc.)

The Right Stuf International Inc., PO Box 71309, Des Moines, IA 50325. Catalog $3. Website: www.rightstuf.com (Unusual *anime* titles)

```
Luton Sixth Form College
Learning Resources Centre
```

A C K N O W L E D G M E N T S

My great thanks to the many people who helped make this book possible.

In Los Angeles: John Woo, Laurence Walsh, Dennis Bartok, American Cinematheque.
In Tokyo: Takeshi Kitano, Naoyuki Usui, good folks at Office Kitano, Tomoaki Hosoyama, Makoto
Kakurai, Shochiku Co., Yuko Moriyama, Niida Satoyo.
In the Philippines: Jose Lacaba, Eddie Romero, Rosanna Roces, Neo Films, Marta Pl.Linot, Reyna
Films, Carlos Siguion-Reyna, Cesar Hernando.
In Seoul: the other Bruce Lee, Dong-A Export Co.
In Bangkok: Grammy Films.

More sincere thank yous:
Robin Holland, Linda Lew, Tai Seng Video Marketing, Jennifer Willmen, Fox Lorber, Fumiko
Takagi, Dennis Doros, Milestone Film, Gwinevere von Ludwig, Arrow Releasing Co., John Ledford,
Janice Williams and A.D.V. Films, Shawne Kleckner, Jeff Thompson, The Right Stuf International,
Triborough Films, Trimark Pictures, Auden Jamison and Inteleg International, Drew Geishecker, Shari
Rosenberg, Janus Films, Criterion, Maria Resurreccion, Regal Home Entertainment, Greg Yokoyama at
Chambara Entertainment, Stephanie O'Neill, Hallmark Home Entertainment, Evergreen
Entertainment, Marjorie Sweeney, Kino International, Grace Kim and New Yorker Films, First Run
Features, Public Media Video, Gretchen Hagle, Denesh Kumar and Asian Video Movies, Renee Tajima,
Kumi Kobayashi and Viz Communications, Pear Sintumuang, Zeitgeist Films, Artistic License Films,
Dean Server, Luis Francia, Norman Wang, Asian Cinevision, Samurai Video, Japanese American Video,
Video Search of Miami, Concord Video, Incredibly Strange Filmworks, Federal Express, and China
Moon Restaurant, Red Bank.

At Chronicle Books: much appreciation and thanks to two inspiring and diligent editors:
Karen Silver, who gave this book life, and Alan Rapp, who made it grow up big and strong.

Thanks, pal: to Marc Lawrence, a great actor, who loaned me his house in Palm Springs, where much of
this book was written.

And more thanks: to Roslyn Targ, a great agent.

And still more:
to my mother and father, and Terri.

P I C T U R E C R E D I T S

The following have provided pictures as illustrations for a critical/historical work and for the promotion
of their materials. All rights and copyrights for the illustrations in this book are maintained by the origi-
nal copyright holders and licensees.

Cover *(Neon Genesis Evangelion)*: © GAINAX/Project Eva., TV Tokyo; pgs. 2–3, 129: Courtesy of Zeitgeist Films;
pg. 4: ©1994 O.B. Planning/Toho Co., Ltd., Courtesy of The Right Stuf International Inc.; pgs. 8, 122, 123:
Courtesy of Trimark Pictures; pgs. 9, 63, 67 (top): Courtesy of Chambara Entertainment; pgs. 10, 11, 80: Courtesy of
Office Kitano; pgs. 12, 13, 18, 26, 27: Courtesy of Kino International; pgs. 14, 15, 21, 23, 24, 35, 37, 38, 39, 40:
Courtesy of Tai Seng Video Marketing; pg. 19: Courtesy of Columbia Tristar Motion Picture Companies; pgs. 22, 25,
45, 53, 119, 126: Courtesy of Robin Holland; pgs. 28, 33, 34: Courtesy of John Woo; pgs. 29, 32, 36 (left, second
from right), 77 (left): Courtesy of Fox Lorber; pgs. 42, 43, 76: Courtesy of Evergreen Entertainment; pgs. 46, 47, 94,
95, 120, 121: Courtesy of Arrow Entertainment Inc.; pgs. 49, 114, 115: Courtesy of First Run Features; pgs. 50, 51:
Courtesy of Hallmark Home Entertainment; pgs. 54, 55, 56, 57, 58, 59, 62, 65, 67 (bottom), 68, 69, 70, 71: Courtesy
of Janus Films; pgs. 60, 61, 78 (bottom): Courtesy of Public Media Video; pg. 72 (top): ©1995 Sho Fumimura-Ryoichi
Ikegama/Shogakukan/OB-Kikaku/Toho/VAP, courtesy of Viz Communications; pg. 72 (bottom): ©1996 Sanctuary
Project, courtesy of Viz Communications; pg. 75: ©1995 Daiei, NTV Network, Hakuhodo; pgs. 75, 84, 86, 87 (left,
second from right, right): Courtesy of A.D.V. Films; pg. 77 (middle and right): Courtesy of Yuko Moriyama, Niida
Satoyo, and Inteleg International; pgs. 78 (top and middle), 79: Courtesy of New Yorker Films; pgs. 82, 83: Courtesy
of Milestone Film & Video; pgs. 84, 87 (left): ©1995 Yuzo Takada/Takeshobo, BS Project, TV Tokyo, NAS; pg. 85:
©1986 Toho Co., Ltd./KK Movic/Ashi Prod., Courtesy of The Right Stuf International Inc.; pg. 86: ©1987 EXE Co.,
Ltd.; pg. 87 (second from left): © 1987 Tezuka Productions Co., Ltd., Courtesy of The Right Stuf International Inc.;
pg. 87 (second from right, right): ©1996 AKC/MRC/A.D. Vision; pg. 89: © 1994 O.B. Planning/Toho Co., Ltd.,
Courtesy of The Right Stuf International Inc.; pgs. 90, 91, 92, 93: Courtesy of T. Hosoyama and Office Border Co.;
pgs. 96, 97: Courtesy of Dong-A Export Co.; pg. 99: Courtesy of Arrow Entertainment Inc.; pgs. 100, 101, 105:
Courtesy of Regal Home Entertainment; pgs. 104, 107: Courtesy of Reyna Films and Rosanna Roces; pg. 108:
Courtesy of Eddie Romero; pg. 110: Photo by L. Server; pgs. 111, 112, 113: Courtesy of Neo Films; pgs. 116, 117:
Courtesy of Grammy Film; pgs. 124, 125, 128: Courtesy of Asian Video Movies Wholesale.